CARLISLE
IMAGES of America

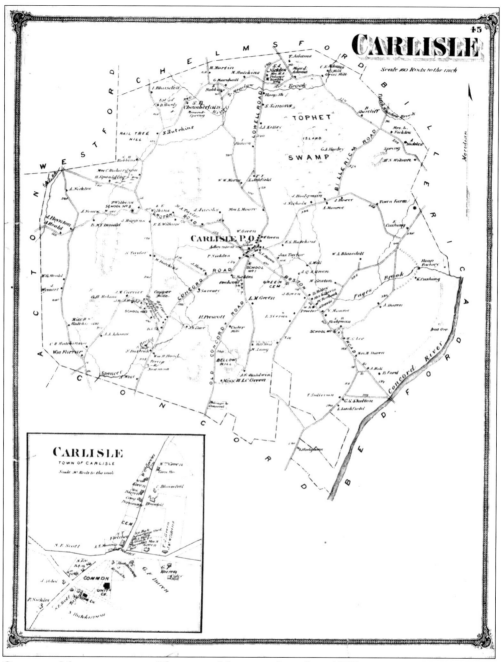

CARLISLE, MASSACHUSETTS. This map of the town dates from 1875.

Carlisle Historical Society

Copyright © 2005 by Carlisle Historical Society
ISBN 0-7385-3709-8

First published 2005

Published by Arcadia Publishing,
Charleston SC, Chicago IL, Portsmouth NH, San Francisco CA

Printed in Great Britain

Library of Congress Catalog Card Number: 2004113066

For all general information, contact Arcadia Publishing:
Telephone 843-853-2070
Fax 843-853-0044
E-mail sales@arcadiapublishing.com
For customer service and orders:
Toll-free 1-888-313-2665

Visit us on the Internet at www.arcadiapublishing.com

On the cover: Capt. Horace Waldo Wilson (center), owner of Wilson Stock Farm, poses with his granddaughter Ethlyn Wilson (in baby carriage) and his workers in an 1898 photograph.

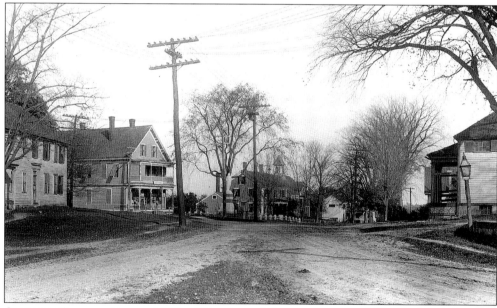

CARLISLE CENTER, EARLY 1900S. This view of the intersection of Westford and Concord Roads looks into Carlisle Center. The Wheat Tavern, or Long Block, is at the left, next to the Carlisle Country Store. The monument at the rotary is almost obscured by the tree in the center. The photographer was Edmund L. French, whose artistry has preserved images of Carlisle for us and future generations. We dedicate this book to his memory.

Contents

Acknowledgments		6
Introduction		7
1.	Farms	9
2.	Businesses	23
3.	Schools	39
4.	Churches	49
5.	Homes	61
6.	Community Life	77
7.	Celebrations	89
8.	Landscapes and Landmarks	97
9.	Fires and Storms	109
10.	People	117

Acknowledgments

In producing this book, the Arcadia Committee—Ellen Huber, Helen Lyons, Constance Manoli-Skocay, Ellen Miller (chair), Virginia (Wilkie) Mills, and Stephanie Upton—learned so much about town history that our hard work and commitment became great pleasure. Discovering previously secluded photographs and documents—largely through community support—and bringing them to light was exciting.

We are grateful to four townspeople whose histories of Carlisle were the foundation of this work: Ruth Chamberlin Wilkins's *Carlisle: Its History and Heritage* (1976); Martha Fifield Wilkins's *Old Houses and Families of Carlisle, Massachusetts* (1941); Sidney Bull's *History of Carlisle, Mass., 1754–1920* (1920); and Donald A. Lapham's *Carlisle: Composite Community* (1970). Without their groundbreaking research, this book would not have been realized.

A majority of the photographs and documents came from the Carlisle Historical Society and the Gleason Public Library collections. We thank the following people for donating their private photographs: Dorothy Clark, Barbara Culkins, Rev. Thomas P. Donohoe, Rachel Page Elliott, Ray Faucher, Nancy and Tim Fohl, Lewis French, Heidi and Vaughn Harring, Bob and Peggy Hilton, Shirley (Wilkie) Jensen, Richard Lamburn, Frances Lapham, Janet Lovejoy, Beverley Macdonell, Connie Metivier, Virginia (Wilkie) Mills, Jean (Wilkins) Shubert, Mary Sleeper, Larry A. Sorli, and Carol Treibick.

Thanks go to Anne Marie Brako, Sarah Brophy, Bob Daisy, Marjorie Johnson, and Angela Reddin for production help, and to Terry Herndon, Helen and Paul Kierstead, Bob Koning, Lee Lockwood, Inga Macrae, Barbara O'Rourke, Irvin Puffer Jr., and Rev. Eugene Widrick for sharing their special historical information.

We proudly present this visual history to the town of Carlisle in its bicentennial year.

Introduction

Carlisle is a town of contrasts. In the town center, historic houses hug the main roads. Away from the center, long driveways lead to large houses sited on a minimum of two acres. On some old roads, weathered barns coexist with million-dollar mansions. Ancient stone walls and Native American relics dot the landscape, while traffic often clogs the narrow roads. Town services are few—no town water, sewage, or trash collection—yet the tax rate is high.

People who choose to live in Carlisle prefer a rural to an urban way of life, and they treasure the farming heritage that has shaped the town. Respect for the environment and stewardship of the land have moved the town to designate approximately 25 percent of its 9,856 acres as conservation land; much of it was farmland that once defined the small community of Carlisle.

This year, 2005, Carlisle celebrates the bicentennial of its incorporation as a town. Before February 18, 1805, the town had twice been a district. In 1754, the northern part of Concord became the First District of Carlisle so that the 60 families in the district could attend "Publick Worship" closer to their homes. Church services were held in Carlisle residences, while plans to build a meetinghouse were discussed but were never realized. Some disgruntled residents favored a return of the district to Concord, and in July 1756, the district voted to do so.

A meetinghouse was erected in the fall of 1758 on land donated by Timothy Wilkins. As was the custom in those pre-Revolutionary times, the meetinghouse was the gathering place for civil matters as well as religious interests, and it served as an unofficial village center where there was actually no legal village.

In April 1780, the Second District of Carlisle was established—Carlisle was now designated a town, sharing legislative representation with neighboring Acton. Several times during the 25 years of the Second District, Carlisle residents considered petitioning the General Court of the Commonwealth of Massachusetts to become a town. Township became a reality on February 18, 1805, when Carlisle was incorporated. At the time, the town was reported to have "one physician, one store, two taverns, and a few mechanics shops" for the needs of the population of 634.

This town's roots are firmly planted in the rocky New England soil. Early settler-farmers cleared the land, built stone walls to delineate their pastures, and struggled against the elements—storms, droughts, floods, fires—to earn their living. Farmers in the 19th century made the daylong trek into Boston and back to sell their produce. Some residents who did not farm made their living from the area's natural resources: mining (copper and granite), mills (sawmills, hoops, and fulling), and lumber. The importance of education was deeply rooted in

the Carlisle community. Residents voted to build schools in each quadrant of the town, and they kept pace with the need for larger schools and better-quality education.

In the early 1900s, Carlisle was a town of farms, schoolhouses, two churches, a store, and wide-open fields. Longtime residents remember being able to see clear across town, and some lived within sight of the Concord River. The roads were dirt and gravel, and residents endured a yearly "mud season" when wagons were mired in mud. Neighbors usually came to their rescue. Children rode to school on horse-drawn barges, open to the elements, and upon arrival at school, rushed for the warmth of the wood stove. The Town Farm cared for the poor; "state girls and boys" were boarded with local families, at town expense, to help with household and farm chores.

The introduction of the automobile to Carlisle *c.* 1909 changed life for those fortunate (and wealthy) enough to have one. Electricity arrived two years later, and it is reported that "one exciting evening in the fall [of 1911] the center of Carlisle was lighted by electricity for the first time."

Also at the turn of the century, Scandinavians began arriving in Concord and Carlisle to work on the large farms, driven from their homeland by economic need. Hardworking and frugal, they would eventually buy their own land and build their own farms. The Larsens, Sorlis, Petersens, and Nelsons took their place alongside the Greens, Healds, Clarks, and Wilkinses, changing and strengthening the fabric of Carlisle. Farm families all, they came together at town meetings to discuss and vote on matters of importance to their community.

Change came slowly to Carlisle, which remained relatively remote since no major roads lead here. In the late 1880s and early 1900s, there were only about 500 inhabitants in town. In 1930, "569 people and 70 horses, 450 cows, 15,980 chickens, 650 pigs and fewer than 50 goats, turkeys and ducks" shared Carlisle lands, according to U.S. Census figures and the Carlisle tax assessors.

After World War II, Carlisle began to change from a farming community to a suburb of Boston and Lowell. The 1940 population was 747. Twenty years later, the population had doubled to 1,500, and it doubled again by 1975. In 1990, the population reached 4,333, and currently it numbers approximately 5,000. Most of today's residents work in white-collar professions, and unlike their predecessors, most work outside of town.

Reminders of Carlisle's agricultural heritage are everywhere—in the few remaining farms; the stone walls, fields, and pastures; grazing cows, horses, and nonresident sheep who come to rid conservation lands of invasive plants; and some roosters who greet the dawn. Many old-time traditions—Old Home Day, the Strawberry Festival, and observances on Patriots Day and Memorial Day—are being carried forward by new generations. They help link native Carlisleans and newcomers—all struggling with 21st-century challenges—to the town's rural legacy and a simpler way of life.

It is the mission of this book to capture Carlisle's visual history through the mid-20th century. We have attempted to present historically accurate information, but often the written histories disagree as to dates, events, and even which people participated in the events. Nonetheless, the photographs will speak for themselves, conveying the remarkably vibrant history of a very special town.

One
FARMS

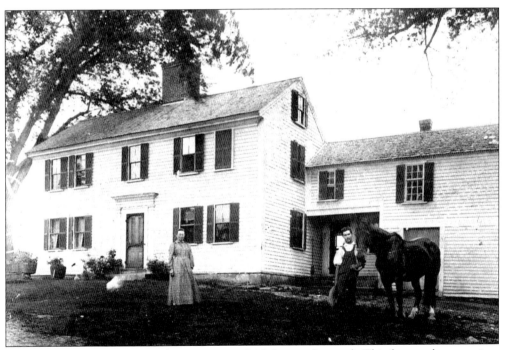

CAPT. THOMAS GREEN FARM (ACROSS FROM 215 SOUTH STREET). This farm no longer exists, but according to records it stood until around the year 1870. Pictured here are Ella Buttrick Green and her nephew, Edgar Hood. The farm's owner, Capt. Thomas Green, was the keeper of the Wheat Tavern for many years and was said to have made a tidy profit. He was elected a representative in the Massachusetts legislature.

PARLIN-SORLI FARM (1022 WESTFORD STREET). The 70 acres of this old farm retain most of their 1744 boundaries. The original house was built c. 1785 by Asa Parlin, who farmed the land from 1781 to 1822. James Emery built the now rare English-style barn c. 1745. In this photograph, James Lovering, the farm's owner from 1904 to 1911, is shown next to his horse. He sold the farm to the Sorlis in 1914.

HELGA SORLI, FARM WIFE. In addition to running Carlisle's first ice-cream stand at the farm, Helga Sorli worked in the fields, as did most farm wives. She came here from Norway in 1902, and, at the age of 17, she married Anders Sorli in 1913. The Sorlis were active in the area's large Scandinavian community, and they belonged to the Norwegian Club in Carlisle. In the 1920s, Concord had two Scandinavian churches.

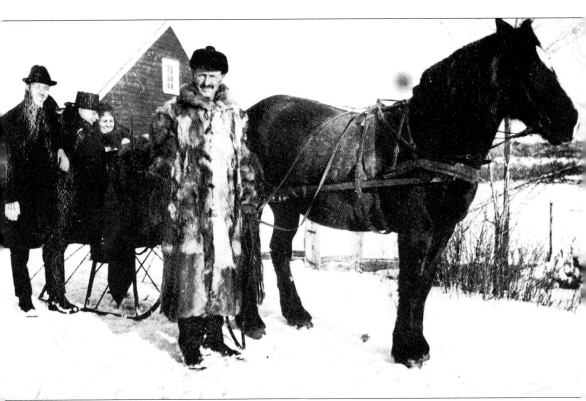

ANDERS SORLI AND FRIENDS. Anders Sorli takes some friends for a sleigh ride on his farm. He wears a full-length raccoon coat and fur hat, which he brought with him from Norway in the early 1900s. He had been a storekeeper in Norway before he came to Boston in 1905, when he was 34. The Sorlis operated one of several successful dairy farms in town; it was continued by their son Lawrence O. Sorli and his wife, Marjorie, who still live in Carlisle.

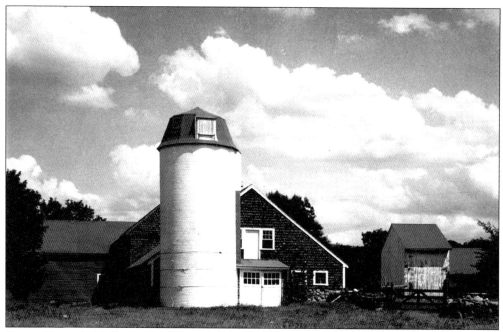

CLARK FARM (185 CONCORD STREET). This farm is one of Carlisle's best-loved icons, with its rolling pastures, classic farmhouse, and landmark barn and silo. The barn once housed 100 cattle, and the structure remains emblematic of the town's rural past. Guy Clark was one of the most respected dairy farmers in the area, and he was a leader in town affairs. The largest meeting room in Carlisle's new town hall bears his name.

CLARK FARMHOUSE. The original house was built between 1742 and 1746 by Leonard Spaulding, was bought by Samuel Green in 1767, and in 1898 was purchased by Guy Clark's mother, Rena Carr, a Carlisle schoolteacher. Guy was born in this house (in the "borning room"), and he and his wife, Dorothy, renovated the farmhouse in the 1940s.

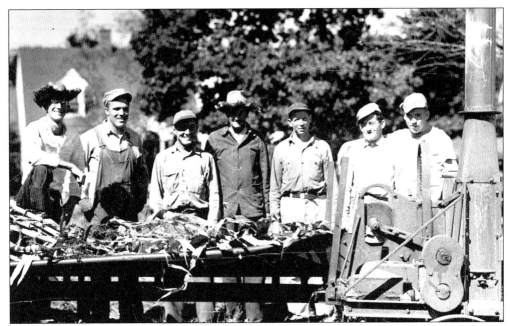

THRESHING TIME AT CLARK FARM. In the late 1940s, workers at Clark Farm pause during the threshing of cornstalks, preparing them for silage. From left to right are Paul Kierstead, Albert Simpson, Ralph Metivier, Charles Kierstead, Guy Clark, Harrison Philbrook, and Bobby Fulton. All except Simpson are from Carlisle.

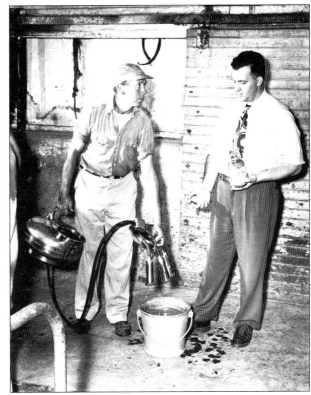

MECHANIZED MILKING. Guy Clark (left) cleans his milking machine as Bradford S. Leach, of the Dairy Laboratory Service in Concord, demonstrates a new cleaning agent. Mechanizing the milking process enabled farmers to increase their herds. Before mechanization, a good hand-milker could milk only seven or eight cows an hour.

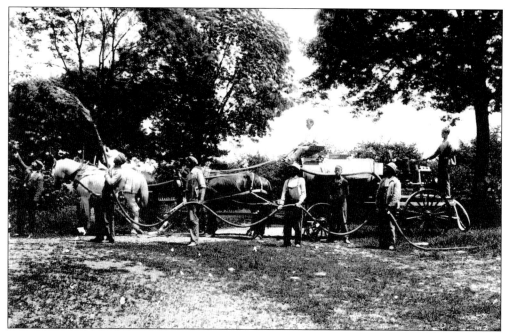

TOWN SPRAYER. This early-1930s photograph depicts the town sprayer and a crew spraying presumably noxious insecticide into the trees. The sprayer was used to combat gypsy moths, brown tail moths, and elm leaf beetles. Members of the crew are, from left to right, as follows: (standing) George G. Wilkins, William F. Robbins, William Hadley, Samuel Kenney, Ray Dodge, and William Lee; (aboard sprayer) Fred Cooke and Benjamin Heald.

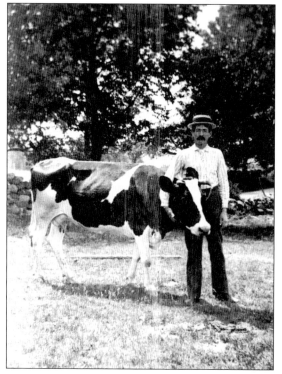

CHARLES SKELTON AND FRIEND. This photograph, taken in the late 1800s, shows Charles Skelton with a prized cow. Charles was the son of George Skelton, who bought River Road Farm in 1888. In 1900, Charles Skelton was one of six forest fire wardens for the town. He succeeded his father in running the sizeable farm.

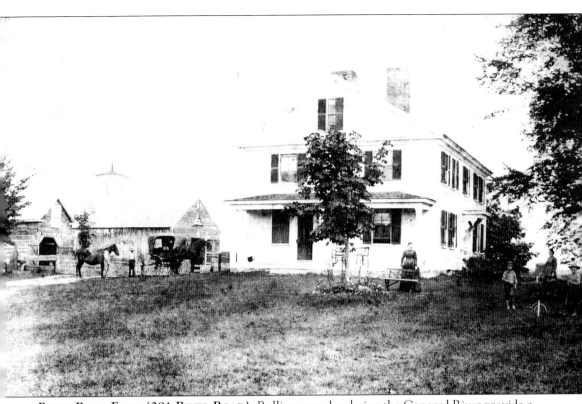

RIVER ROAD FARM (291 RIVER ROAD). Rolling acres bordering the Concord River provide a peaceful setting for this Colonial house and barns. From 1918 to 1943, this was the 360-acre home of Mason Garfield (grandson of Pres. James A. Garfield), who owned "the finest herd of Jersey cattle in New England." The Garfield Dairy was one of several successful dairies in Carlisle. The house was built by Thomas and John Hodgman soon after the Revolutionary War. The structure was divided in the early 1900s—the other half of it was moved down River Road and became the old Henry Hosmer residence. After a disastrous fire in 1918 destroyed the main barn, Garfield rebuilt it; yet another fire in 1936 destroyed the cow barn. In 1946, the farm was sold to Dr. Mark Elliott and his wife, Rachel. The Elliotts did not farm, but they did rent their spacious pastures to Carlisle farmers. The property was renamed Riverside Farm by the Elliotts.

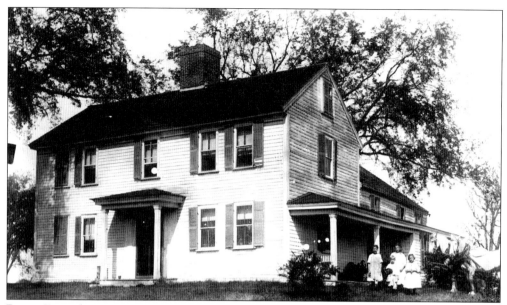

BATES FARM (341 BEDFORD ROAD). In 1660, Robert Blood operated a sawmill at this site, and later, the Green family and then the Blaisdells operated hoop mills here until 1903. Isaac Blaisdell built the house in 1814, and generations of Blaisdells lived and farmed here. This 1912 photograph shows the children of Edgar I. Blaisdell. Richard B. Bates bought the property in 1921 and later established one of Carlisle's most successful dairy farms.

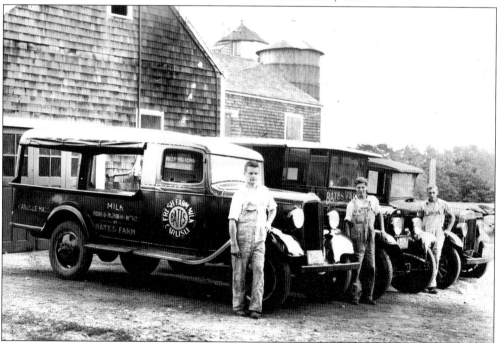

BATES FARM MILK DELIVERY. Bates Farm is a significant landmark, notable today because Kimball's Ice Cream does a brisk seasonal business at the site. Beginning in the 1940s, Bates Farm delivered milk to almost all of Carlisle, including the schools, and to many surrounding towns. Before refrigeration, milk was kept cold with ice stored in one of Carlisle's three icehouses.

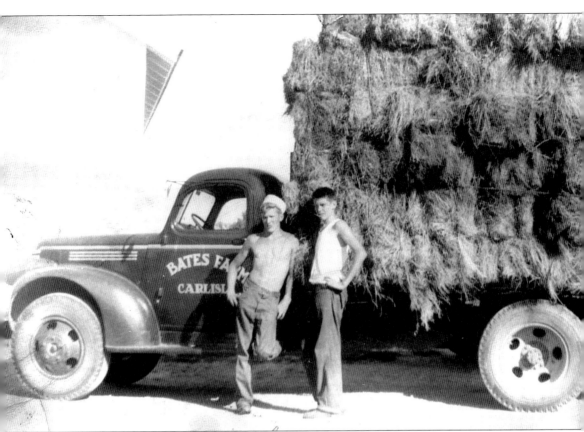

BATES FARM HAY WAGON. Herbert D. Bates (left), son of Richard B. Bates of Bates Farm, and George I. Otterson Jr., grandson of the town's last blacksmith, Ingwald Otterson, take a break next to the farm's 1946 Chevrolet truck, which is heavily loaded with baled hay. Herb Bates was appointed Carlisle's first police chief in 1960, while he was also a selectman.

TOWN FARM (745 EAST STREET). Carlisle took care of its paupers in the 18th century by auctioning their care to families who sheltered them inexpensively. In 1852, the town purchased a 162-acre farm, where paupers and tramps were cared for by a superintendent and his wife. In 1880, 510 tramps and 6 paupers were supported by the town. Eventually the house deteriorated and was replaced. In 1925, the Town Farm was sold and became a private residence.

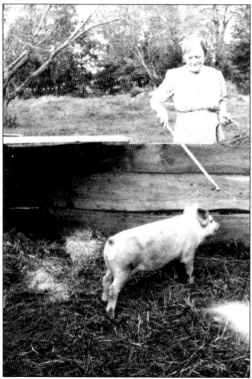

FATTENING THE PIG. It was a necessity for farm families to be self-sufficient in the 19th century and early part of the 20th century, so most farmers kept a pig or two to be slaughtered in the fall for winter dinners. Here Emma Taylor Lapham feeds the family pig. Some farmers raised pigs— there was a piggery in Carlisle until at least 1960. There is even a Piggery Road on the southeast side of town.

GREAT BROOK FARM. In 1939, Carlisle businessman Farnham Smith began acquiring farms in the northern part of town with the goal of raising purebred Holsteins. He and his wife, Susan Smith, developed Great Brook Farm, which, by the early 1950s, became one of the biggest and best-rated dairy farms in New England. Its much sought-after Holsteins were sold all over the world. In its heyday, the farm had 160 head of cattle, and milk was sold to local dairies. In 1974, the Commonwealth of Massachusetts purchased Great Brook Farm from the Smiths and, according to one brochure, created a state park "to protect a piece of New England's rich farming history and to preserve this important agricultural and recreational landscape for future generations." Today, these 940 acres of farmland, woodland, and trails of Great Brook Farm State Park are among Carlisle's greatest natural treasures and are enjoyed by visitors from all over.

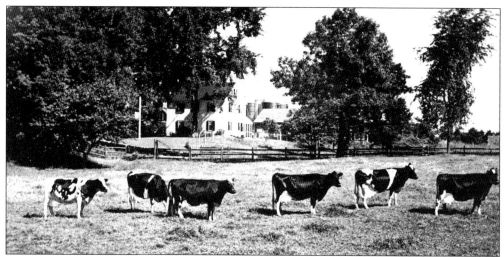

COWS ON PARADE. This bucolic scene at Great Brook Farm in the 1950s represents both the prosperity of the dairy industry in Carlisle in the 20th century and the rural character of the town. Today, there are still cows in the pastures at Great Brook Farm, producing milk for the popular ice-cream stand run by the Duffys, who manage the farm.

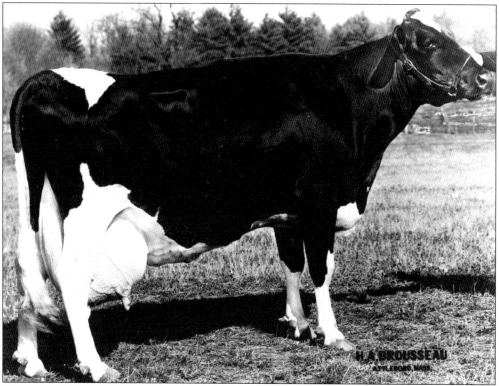

PROSPERA. This champion Holstein-Friesien cow was Great Brook Farm's top prize winner time and again. She produced more milk than any cow in the Holstein-Friesien Association or, "in the whole world, as far as I know," said her former owner, Susan Smith, wife of Farnham Smith, who developed Great Brook Farm. Prospera is buried in a marked grave near the entrance to the farm.

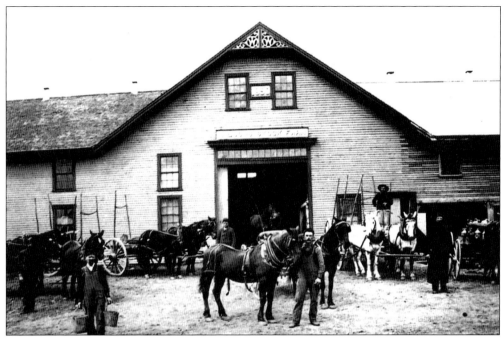

WILSON STOCK FARM (84 SOUTH STREET). Capt. Horace Waldo Wilson (far right) built this huge barn in the late 1880s for his sizeable herd of cattle. He also ran a lumber business and operated a portable sawmill. The property was originally the Capt. Jonathan Heald Farm. Dr. Lawrence Lunt, a Carlisle psychiatrist, bought the farm in 1928 and transformed the barn into his private sanitarium, Valleyhead Hospital.

TOWLE'S CATTLE. Dr. George Towle, physician and surgeon, lived atop a hill on Westford Street. Having grown up on a farm in New Hampshire, Towle continue to pursue his love for cattle, raising Herefords and western cow ponies on his 150-acre farm. Towle and his neighbor, Lawrence O. Sorli, built a "cow tunnel" under Westford Street in 1914 to allow the cattle to reach pastures on the opposite side of the road.

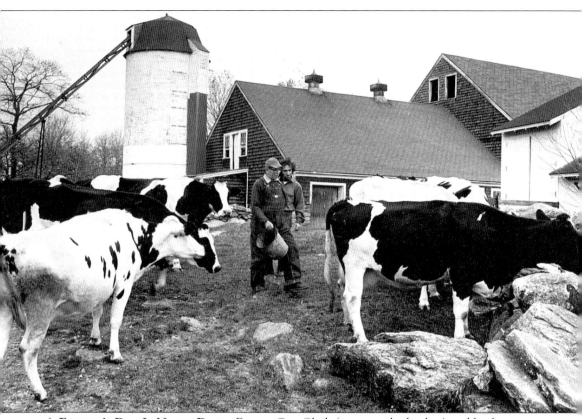

A Farmer's Day Is Never Done. Farmer Guy Clark (carrying the bucket) and his longtime helper, Bobby Morrill, tend to the cows at Clark Farm. From the town's earliest days, the farmer was the backbone of Carlisle life, and farming was the community's primary occupation. Today, only a few farms remain to remind us of the town's rural heritage, but the spirit of yesterday's farmer lives on in the pastures, fields, woodlands, and stone walls of this still small, rural town.

Ode to the Farmer

I have fruits, I have flowers
I have lawns, I have bowers
And the lark is my morning alarmer.
So jolly boys now, "Here's God bless the Plough
Long life and success to the farmer."

—Joseph Palmer

Two
BUSINESSES

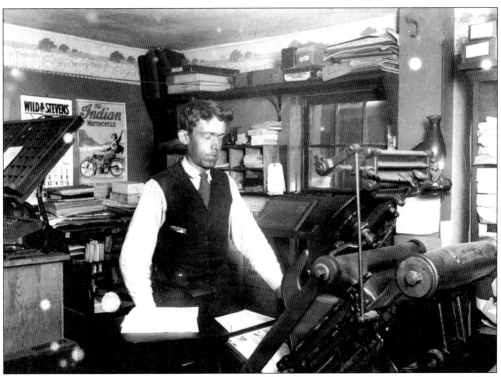

EDMUND L. FRENCH AT HIS PRINTING PRESS. Although not known for its businesses, Carlisle has had many, all vital to the community. Throughout his lifetime, Edmund L. French operated the Wayside Press at his home, 104 River Road. There he printed the Old Home Day programs, warrants for town meeting, and programs for the Grange. His business flourished, and at times he reportedly had to turn away clients.

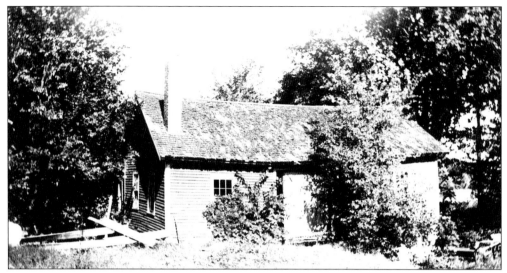

E. B. ROSE & SON HOOP MILL. Elmon B. Rose built his mill on the site of the 1691 fulling (felting) mill on River Meadow Brook, near 886 Lowell Street. In 1889, Rose advertised birch "strapping hoops for shoe boxes" at a cost of $1 per 1,000 feet. At that time, three other Carlisle hoop mills were supplying hoops to meat-packing plants in nearby Somerville and to orange growers in Florida.

MILLSTONE. From 1830 to 1860, Capt. Thomas Page, for whom Page's Brook is named, operated a gristmill on the Andrews-Greenough estate. This headstone in Sleepy Hollow Cemetery has been identified as one of the two grinding stones that were removed from the gristmill in 1885. However, this point appears subject to debate. In their respective histories of Carlisle, author Martha Fifield Wilkins contends both of the gristmill stones became garden ornaments, while author Donald Lapham believes this headstone actually came from the 18th-century Adams-Barrett Mill on North Road.

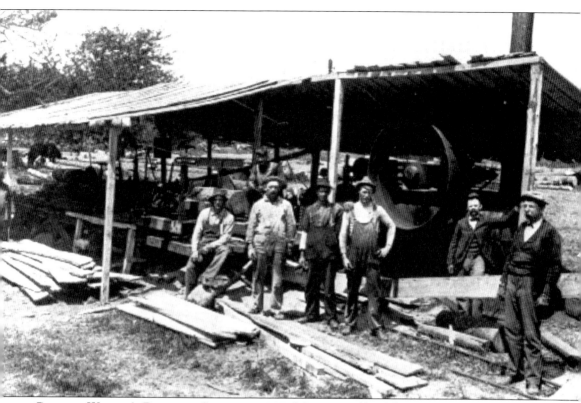

Captain Wilson's Portable Sawmill, 1899. Like many of his fellow farmers, Capt. Horace Waldo Wilson (far right) owned other enterprises besides his prosperous Wilson Stock Farm. A carpenter and builder before coming to town, he engaged in the lumber, wood, and contracting businesses as he farmed. Sometime during the 1870s or 1880s, he built a house for Nathan Buttrick Jr. (owner of Buttrick's Mill) at 922 Concord Street. In 1881, Wilson paid for construction of a new house on the Town Farm for the poor. Martha Fifield Wilkins writes, "Captain Wilson was considered a shrewd businessman, and it was said of him that no matter what he undertook, he never lost money on it." He continued in the long tradition of sawmills, which had been operating in town since the 1600s. By the end of the 19th century, portable sawmills with movable saw blades were replacing the traditional ones that had stationary heads. It is reported that one such mill attracted great attention in 1898, when it cut 200,000 feet of wood in just two weeks' time.

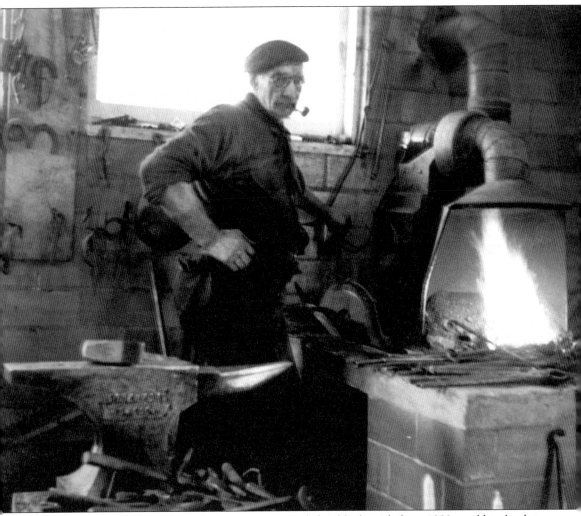

INGWALD OTTERSON. Ingwald Otterson was Carlisle's blacksmith from 1899 until his death in 1936. He forged his own horseshoes instead of buying them from other blacksmiths. As the need for horseshoes decreased when automobiles came to town, Otterson turned his talents to decorative ironwork, including lawn ornaments and boot scrapers. He also offered classes in blacksmithing.

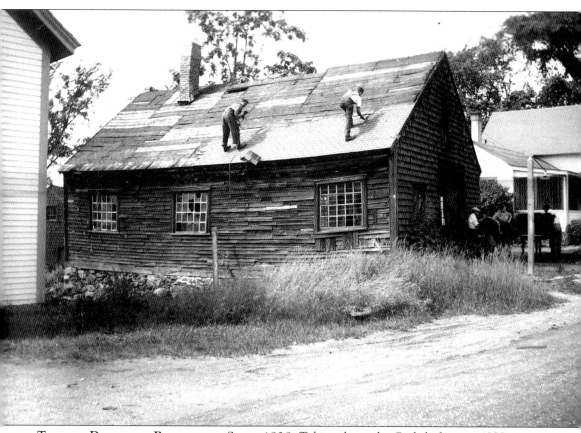

TEARING DOWN THE BLACKSMITH SHOP, 1938. Taking down the Carlisle forge in 1938, two years after blacksmith Ingwald Otterson's death, marked the end of an era. This building, which stood between 14 and 28 Concord Street, served as the local smithy for generations. William Durant first opened a forge here during the 1830s. He was one of many town blacksmiths, dating back to the mid-1700s. Otterson's work lives on in Carlisle, since many old-time residents have pieces of his decorative iron craft—fireplace sets, weather vanes, candleholders, and the like. The First Religious Society has a pair of elegant candelabras created by Otterson and donated to the church by his daughter, Ida Martin.

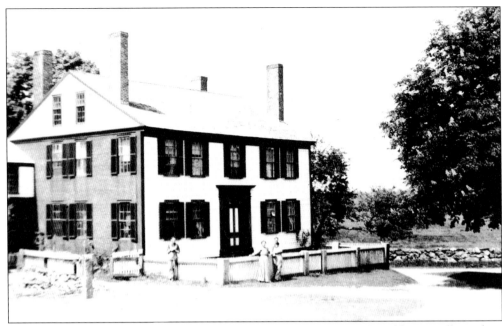

AARON ROBBINS TAVERN (8 ACTON STREET). This impressive brick-end house still stands at the intersection of Acton and Westford Streets. Built in 1820 by Capt. Aaron Robbins, it was operated as a tavern until c. 1830. Its wide front door allowed whiskey barrels to be rolled directly into a huge hall. Located on the busy road from Groton to Boston, the tavern accommodated farmers who were driving their pigs and turkeys to market.

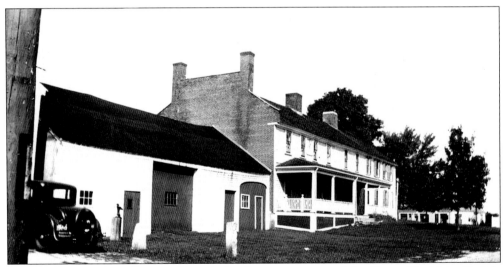

WHEAT TAVERN (7–9 LOWELL ROAD). In the western part of the "Long Block" in Carlisle Center, Lt. Daniel Wheat built a residence and store in 1781 that evolved into a tavern, thanks to its central location. Reportedly as many as 100 travelers at a time stopped here. In the 1920s, Nettie Wilson ran a canning kitchen here and later operated a tearoom with her son, Waldo Wilson.

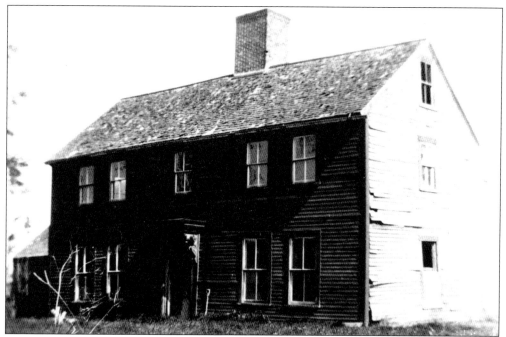

REVOLUTIONARY TAVERN (FORMERLY ON STEARNS STREET). Built in 1759 by Nathan Green on what was then the main road from Billerica to Concord, the tavern reportedly catered to both British soldiers and local Colonials, who gambled together under the apple trees. The rebels supposedly buried four cannonballs under a nearby elm tree. In the late 1880s, the tavern was used as a school. By the mid-1900s, it had fallen into disrepair and was taken down.

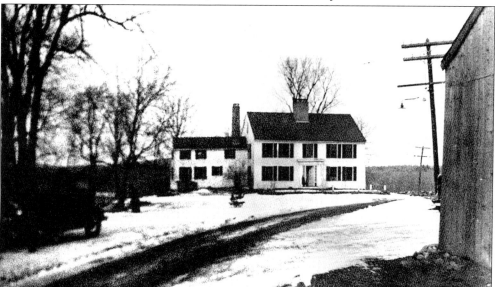

RED LION TAVERN (621 WEST STREET). John Heald built this tavern in 1771 to serve travelers on the old road from Concord to Groton. It remained in the Heald family until 1924. The building featured many fireplaces, two huge ovens, beautiful wood paneling, and small-paned windows. In 1935, the tavern was moved to its present location across the street and was lovingly and carefully renovated to preserve the old tavern's unique character.

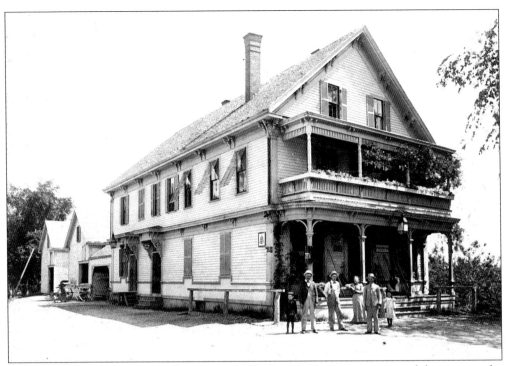

CHAMBERLIN AND ANDERSON STORE, C. 1899. Lars Anderson, co-owner of the store at the time, is pictured second from the left. George Smith, a clerk, is second from the right. The country store held not only the post office but also a public pay phone, as the sign states. It was the first telephone installed in town in 1895, but since few people had telephones, customers would not have called in their orders.

RECEIPT FROM CHAMBERLIN BROTHERS STORE. In 1892, Daniel L. and Warren B. Chamberlin purchased Sidney Bull's store, which once stood on the corner of Bedford Road and Lowell Street. The brothers operated the establishment together until 1898, when Warren briefly sold his interest to Lars Anderson. The business was very much a general store, offering not only groceries but hardware, wallpaper, and clothing as well.

D. L. CHAMBERLIN

Groceries, Hardware, Dry Goods,

Footwear, Poultry Supplies, Stock Remedies,

Stationery, Drugs, Painters' Supplies.

CARLISLE, - - MASS.

BUSINESS CARD OF D. L. CHAMBERLIN. Daniel Lang Chamberlin (who had left the store to farm) resumed the role of shopkeeper when his brother took ill in 1908. Daniel served as postmaster and provisioner at various locations until his death. His daughter, Ruth Chamberlin Wilkins, recalled that in 1910 his store had an innovative wooden refrigerator with compartments for ice, lard, butter, cheeses, and, in summertime, cool drinks like Moxie.

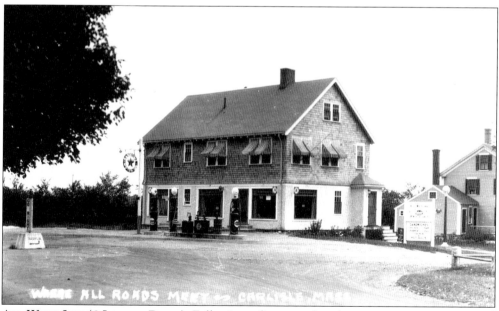

ALL WAYS INN (8 LOWELL ROAD). Following a disastrous fire, the country store site remained vacant between 1925 and 1928. Then Charles W. Dunton built this structure, where he and his wife ran a lunchroom and ice-cream parlor until 1930. At that time, Mr. and Mrs. Fred Daisy purchased the property and continued operating the lunchroom, offering sandwiches, homemade pies, and desserts. Ferns Country Store today continues the store-in-the-center tradition on the Dunton site.

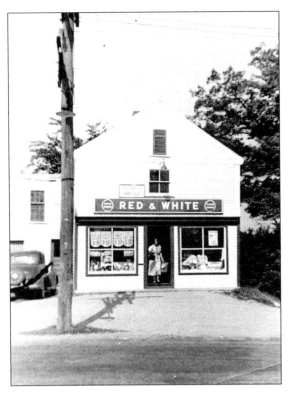

RED AND WHITE STORE (9–11 LOWELL ROAD). Carlisle has had a tradition of country stores since the 19th century; at times there have been two stores in the center. Daniel Lang Chamberlin opened the Red and White store in his remodeled barn in 1926 and operated the business until his death at 81 in 1940. He also served as postmaster for Carlisle. Although it was one of the very first "chain" markets, the Red and White kept its small-town flavor.

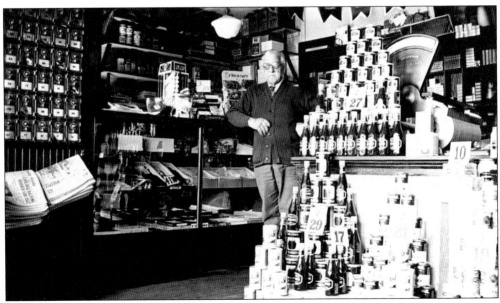

DANIEL L. CHAMBERLIN IN HIS RED AND WHITE STORE, 1931. The post office boxes are to the left. Behind Chamberlin are two of Boston's own candies: Schrafft's chocolates, for 5¢, and Necco wafers, three for $1. When Chamberlin first opened the Red and White store, James Houlton was operating a store across the street. In 1925, a severe fire destroyed Houlton's store, and he left town.

FRED AND ELIZABETH DAISY, 1930. Fred and Elizabeth Daisy of Roslindale were out driving one day in 1930. They got lost along the way, found themselves in Carlisle, saw Dunton's store for sale, borrowed $15,000 from an aunt, and bought the business. Young and enterprising, the couple ran the small lunchroom, pumped gas out front, and raised their family above the store. In 1940, Fred took over duties as the town's postmaster, and the post office was moved from across the street and relocated in the north room of the building. After Fred Daisy died in 1946, Elizabeth Daisy ran the post office and the restaurant until a new postmaster was appointed. Since the family lived above the store, daughter Barbara Daisy Culkins recalls, "We never sat down to a meal without someone wanting something." After two robberies, Mrs. Daisy decided she would no longer run the restaurant. The family leased the business to a succession of shopkeepers until 1993, when Fred and Elizabeth's daughter-in-law, Alice, and her two sons opened Daisy's Market on the premises. Today, Larry Bearfield and Robin Emerson, owners of Ferns, continue the long tradition of Carlisle shopkeepers on this site, which is still owned by the Daisy family.

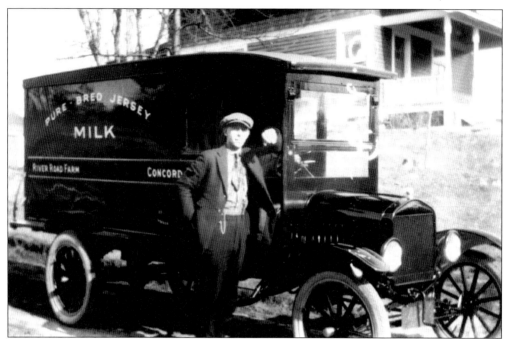

RIVER ROAD FARM DELIVERY TRUCK. Dairy farms depended upon the milkman to deliver milk and other dairy products to their customers. Carlisle's Edmund L. French drove the milk truck for neighboring River Road Farm, which was owned by Mason Garfield, grandson of Pres. James Garfield.

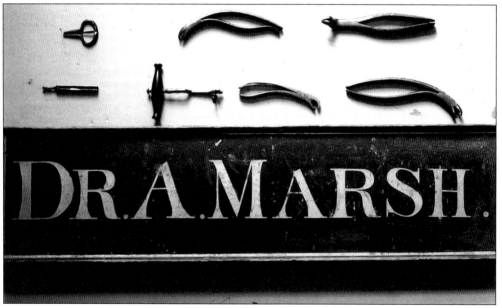

TRADE SIGN AND TOOLS OF DR. AUSTIN MARSH. Dr. Austin Marsh was Carlisle's physician for 60 years, from 1838 to 1898. In an age before "specialization," he practiced not only medicine but also dentistry (note the tools) and pharmacology. This sign might have hung at the house he built in 1879 at 46 Lowell Road. In the true tradition of country doctors, Marsh would saddle up his horse and make house calls.

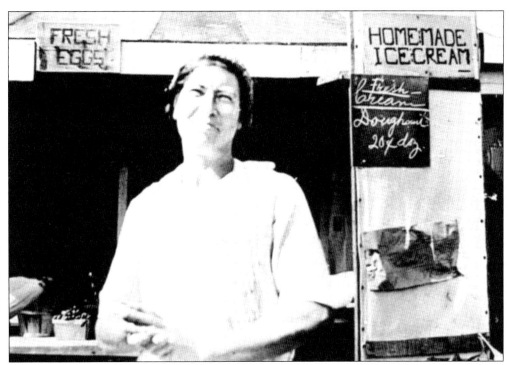

HELGA SORLI, 1932. Carlisle's first ice-cream stand was located on the Sorli Farm, at 1022 Westford Street. Helga and Anders Sorli took advantage of the prime location along a frequently traveled road to set up a roadside stand. In addition to fresh produce, eggs, and cream from their farm, they sold homemade doughnuts and ice cream.

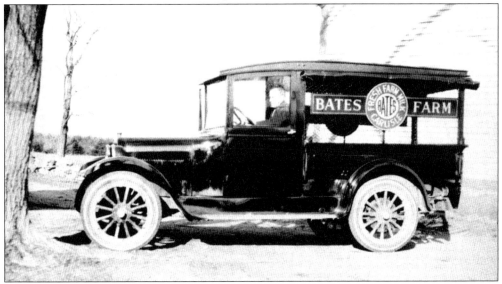

BATES FARM DELIVERY TRUCK. Herb Bates recalled that his father delivered milk to "most everyone in Carlisle at one time or another and also had the milk contract for the school." The delivery business quickly grew to include towns such as Medford, Winchester, Arlington, and Lexington. "All milk was produced, processed, pasteurized, homogenized, bottled, and delivered house to house seven days a week," Herb added.

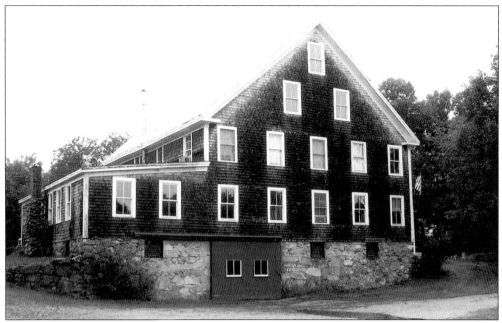

CRANBERRY BOG HOUSE (OFF CURVE STREET). The Nickles brothers, James W. and W. Clifford, built this structure in 1905 for their cranberry business. It was known then as the Squash House, perhaps because they used to store squash and pumpkins there. It is said that dances were held on the top floor of the house.

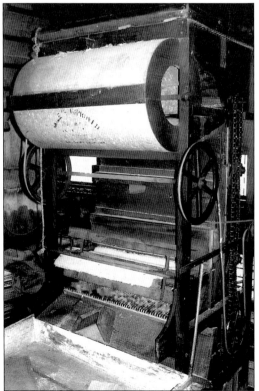

CRANBERRY SORTER. The Bailey cranberry separator performed one of many important steps in cranberry harvesting. After the berries were dry-picked by workers using hand-scoops, the cranberries were cleaned, put through screening machines, and then scrutinized by female workers who completed a final hand-sorting. In the 1940s, much of the fall picking was done by Carlisle residents, with help from the prisoners of war housed at Fort Devens. The separator is still used today.

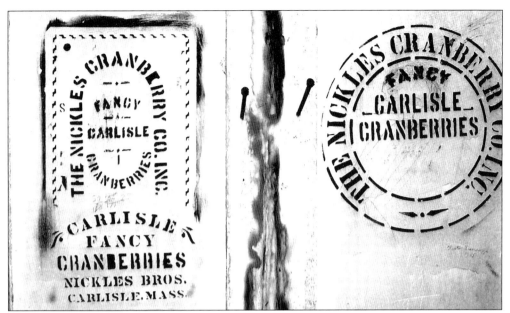

NICKLES CRANBERRY COMPANY STAMP. W. Clifford and James W. Nickles, sons of Gilman Nickles of Carlisle, purchased more than 400 acres in 1903 to establish a cranberry business. They bought water rights to Heart Pond, began cranberry production in 1904, and incorporated their business in 1912. The bog has been in continuous operation ever since; most of the cranberry plants there today are from the Nickles brothers' stock. Until the 1980s, berries were dry-harvested; now most of the berries are wet-harvested for use in juices and prepared products.

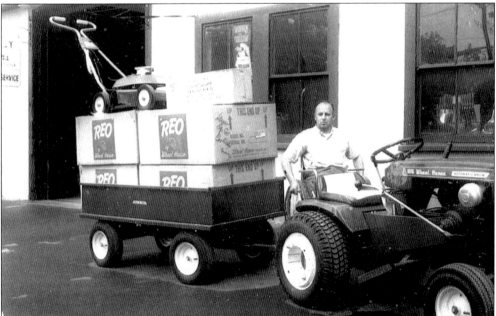

SLEEPER POWER EQUIPMENT COMPANY (18 WESTFORD ROAD). During the 1950s and 1960s, Carroll Sleeper (shown here) operated a riding tractor dealership on the site of the former Russell's Repair Shop in Carlisle Center. Sleeper was partially paralyzed, and he specialized in redesigning tractors and equipment for the physically challenged.

VALLEYHEAD HOSPITAL (84 SOUTH STREET), C. 1950. From 1929 to 1978 Valleyhead Hospital offered psychiatric care to an exclusive clientele. Dr. Lawrence Lunt, a Carlisle psychiatrist, purchased the 100-acre Wilson Stock Farm to build a private sanitarium for patients with acute depression, schizophrenia, "adolescent maladjustment," and alcohol and drug addiction. The facility provided patients with recreational therapy as well as medical treatments, including the controversial electroshock therapy. Lunt operated the sanitarium until 1947, when a new organization took over. Valleyhead cared for approximately 40 to 70 patients and employed 90 full- and part-time staff members. Carlisleans worked in the kitchen, dining room, laundry, and maintenance department. Sarah Andreassen, who worked there as a high school student, recalled the beautiful building: "They converted the barn [her great-grandfather's] into a lovely building; the staircase wound round and round. There was a grand piano, lots of nice plushy, comfortable sofas and chairs." Only a very small wooden sign advertised the presence of this hospital. Although records are confidential, it is rumored that Valleyhead treated its share of famous people, including author Sylvia Plath, comedian Jackie Gleason, and Jacqueline Kennedy Onassis. Today, Assurance Technology Corporation is located at this site.

Three
SCHOOLS

HIGHLAND SCHOOL STUDENTS. Before 1880, teachers hired by the local districts taught Carlisle students in private homes. As the student population grew, each district voted to build a schoolhouse; by 1840, five district schoolhouses were in use. After a subsequent increase in student numbers, Carlisle moved its children and schoolhouses to the town center and assigned students by grades to three separate buildings. The Highland School was built in 1908 to serve all the Carlisle students.

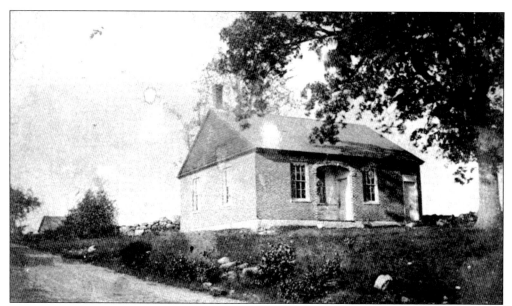

NORTH SCHOOL. This photograph is dated 1907. In 1828, voters of the North District of Carlisle agreed to build a new schoolhouse on the site of an older wooden structure at the corner of Lowell Street and North Road. The new brick school was completed at a cost of $553.62. The structure was extensively repaired in 1869, and it remained in use until the turn of the century, when all students were sent to the center schools. The North School building is currently used as offices by Great Brook Farm State Park.

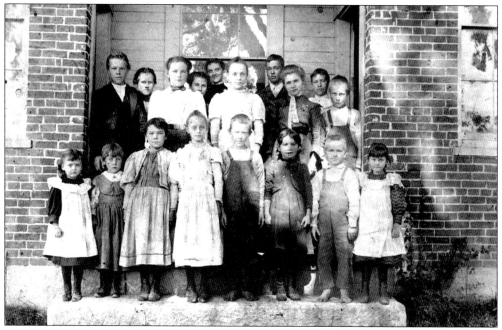

NORTH SCHOOL STUDENTS. The North School was the last of the five district schools to remain in operation when the school districts were consolidated. In 1898, fourteen students from Carlisle and three from Chelmsford attended the one-room schoolhouse. The students pictured here c. 1900 represent one of the last classes to attend the North School.

EMELINE PARKER. In 1828, when the new North School building was constructed, school was generally taught in winter and summer terms. Male teachers were employed during the winter term, when many older boys (freed from farm work) were in attendance, while a schoolmistress usually taught the summer term. Parker was hired at age 16 to teach during the summer term at the "new" North School.

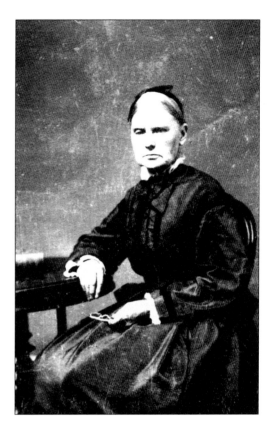

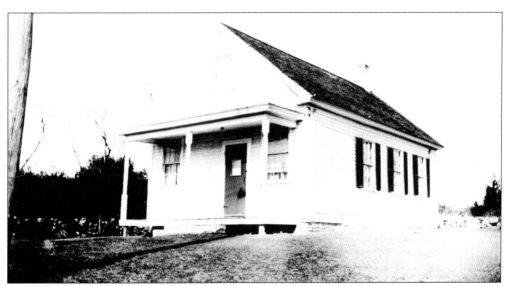

SOUTH SCHOOL. In 1839, the South District voted to build a local schoolhouse. The school was destroyed by fire in 1886, and its replacement (shown here) was built the following year. Beginning in the 1890s, students from the South District were transported to the center for classes, and the South School was sold by the town. The building at 152 South Street is currently a private residence.

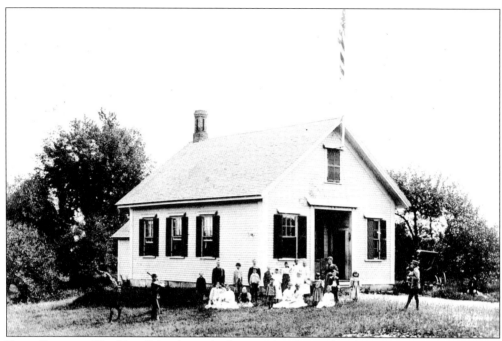

EAST SCHOOL. The East School was built in 1869 after a fire destroyed the original 1839 structure. In the 1890s, the East School building was moved to the center of town (adjacent to the Red Brick School), where it housed the upper four grades. In 1908, after the Highland School was built, the East School was sold and was then moved to 371 East Street.

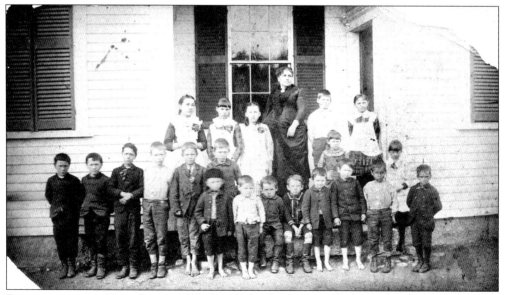

STUDENTS AT THE EAST SCHOOL. The East School was originally located in the triangle at the intersection of Maple Street and Bedford Street, before the building was moved to the center of town. This class portrait was taken c. 1885 by well-known photographer Charles Hodgman of Carlisle. Hodgman, who had a studio in Bedford, photographed and produced many postcards of the period.

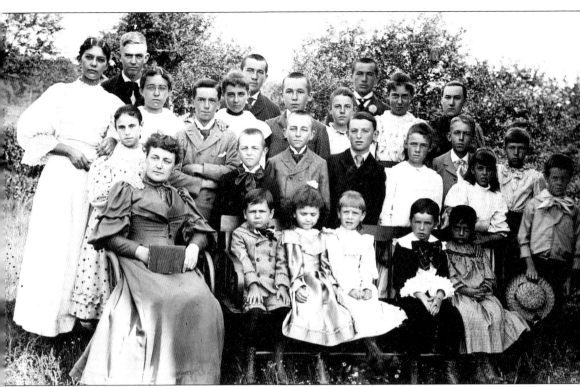

EAST SCHOOL CLASS PORTRAIT. Students are pictured c. 1898 with their teacher, Martha Smith. From left to right are the following: (first row) Martha Smith, Joseph Liberty, Anna Liberty, Anna Hansen, Roy Hodgman, and Margaret Cuneo; (second row) Sadie Woodward, Leslie Rounds, Will Rounds, Maurice Ticknor, Winifred French, Ed French, Hattie Hodgman, Anna Hansen, and Andrew Hansen; (third row) Gertrude Hammond, Herbert Lee, Pansy Hammond, Sidney Davis, Edith French, Alice French, and Emma Davis; (fourth row) Lillian Hammond, George Skelton, Austin Davis, and Albert Davis.

WEST SCHOOL. The West School was built across from 63 Acton Street in 1840, and it remained in service until the 1890s, when the West School students were transported to schools in the town center. In 1908, town meeting voted to sell the schoolhouse, which was subsequently used as a residence until it was struck by lightning and burned down in 1932.

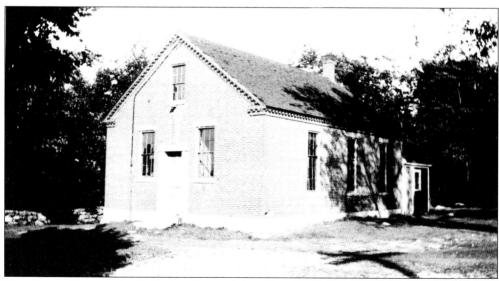

RED BRICK SCHOOL. In 1848, the Centre School District voted to replace the original 1818 Centre School with a new building. The new Brick School, measuring 39 by 27 feet, was built on land donated for that purpose by William Green. The building remains in use by Carlisle Public School at the school complex.

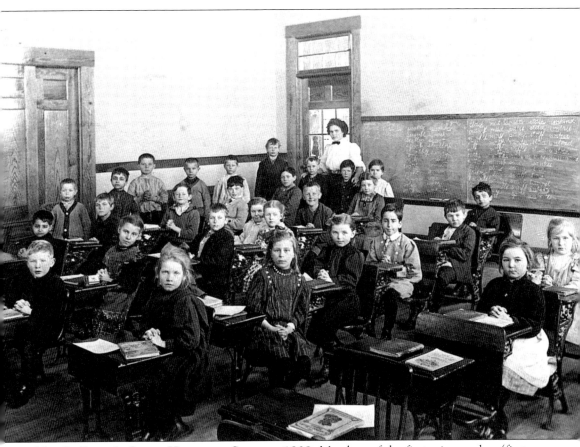

MISS LaFLEUR'S CLASS, HIGHLAND SCHOOL, 1909. Members of the first primary class (first, second, and third grades) pose here. From left to right are the following: (first row) Florence Clark and Odlang Olsen; (second row) Jennie Koford, Cora Buttrick, Ruth Chamberlin (Wilkins), Robert Roby, Clarence Dawes, and Isaac Jacobs; (third row) Alexander Olsen, Hazel Davis, Frank Miller, Gladys Hood, Alfred Pedersen, and unidentified; (fourth row) unidentified, Francis Dutton, Hawthorne Billington, Alfred Long, Archer Lovering, unidentified, and Sterling Davis; (fifth row) Guy Clark, George Jacobs, three unidentified pupils, and teacher Miss LaFleur.

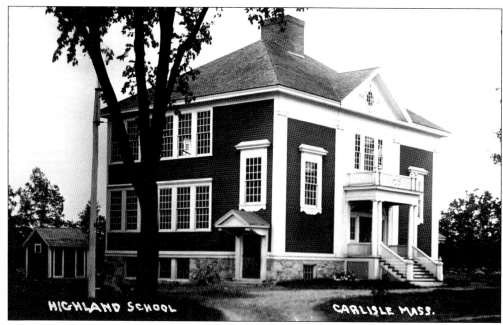

HIGHLAND SCHOOL. In 1908, the town voted to build a single schoolhouse, which would house all of the town's students in a new "graded" system. Erected that same year, the Highland School had four classrooms, a teachers' room, basement playrooms, and a heating plant. Students first attended classes here in December 1908. The building, located within the Carlisle Public School complex, currently houses several artists' studios.

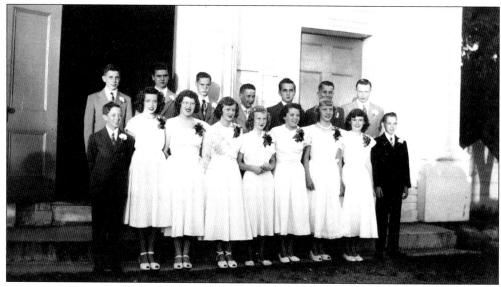

HIGHLAND SCHOOL GRADUATION, 1949. Graduates assemble in front of the First Religious Society. From left to right are the following: (first row) Richard Lamburn, Marilyn MacDonald, Beverly Dutton, Patricia Durgin, Marion Harrison, Beverly Porter, Jennie Ohs, Jean McAllister, and Murray Heald; (second row) Alfred House, Bobby Daisy, Walter Otterson, Tony Manella, Roger Davis, Douglas Dutcher, and Norman Davis.

HIGHLAND SCHOOL GRADUATION PROGRAM, 1915. After eight years of grammar, arithmetic, history, physiology, drawing, and music, Carlisle eighth-graders were ready to move on to high school in an adjoining town, usually Concord. Commencement day in Carlisle was a festive occasion. Events included recitations, speeches, and musical performances, and concluded with a solemn ceremony at which diplomas were awarded.

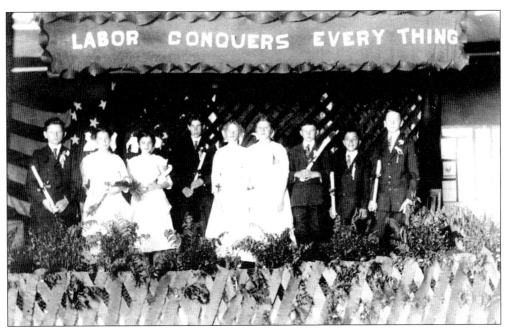

HIGHLAND SCHOOL GRADUATION, 1915. Shown in this class photograph are, from left to right, John L. Carr, Mildred A. Hall, Jennie M. Koford, Clarence Dawes, Grace J. Reed, Gladys M. Sargent, Frank O. Miller, Jacob E. Jacobs, and George L. Otterson Jr. The banner spells out the class motto: Labor Conquers Everything.

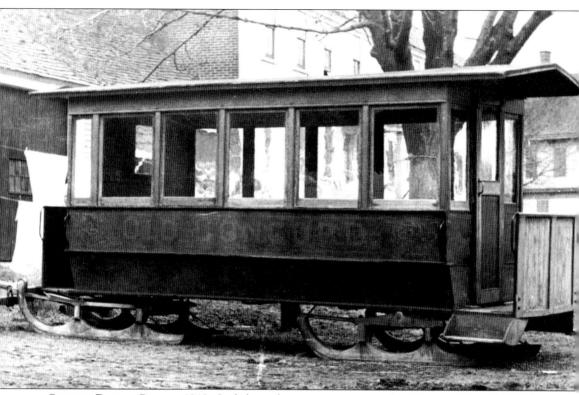

SCHOOL BARGE. Prior to 1919, Carlisle students were transported to Concord High School in a covered barge that was drawn by two horses. Edward Tuttle, who lived in the house just west of the Wheat Tavern, drove the barge for many years. The barge was not heated, but blankets were provided to passengers. In the winter, crews of men with shovels removed the snowdrifts in advance of the barge. At least twice during one winter, the barge tipped over because of high drifts. It was not unusual in snowy seasons for the students to spend three or four hours per day on the road. Pictured here, the "Old Concord," which maneuvered the snow-covered roads on runners, was originally used by the philosophers who rode in it from the Concord depot to the School of Philosophy on the Alcott Estate. In this photograph, the Wheat Tavern and the old Carlisle Country Store are in the background.

Four

CHURCHES

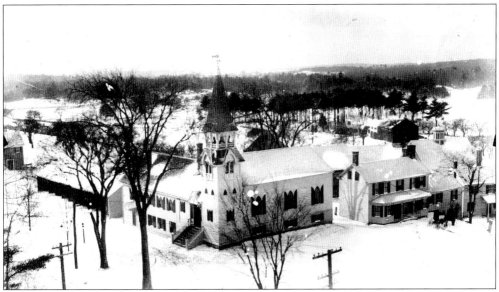

CARLISLE CONGREGATIONAL CHURCH, 1914. Formed as the Union Calvinistic Society in 1830, the congregation built its church at the southwest corner of Church and School Streets in 1832 at a cost of $800. In 1882, the east end of the building was extended by 10 feet, and the present steeple was installed. In 1912, the entire church was raised four feet to make it a two-story building, and the chapel was added on the south side. In 1903, the church changed its name to the Carlisle Congregational Church.

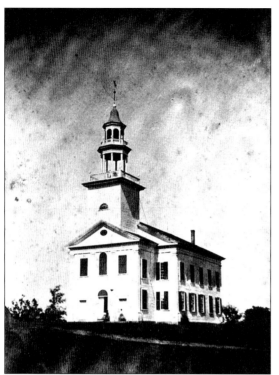

THE FIRST RELIGIOUS SOCIETY, PRE-1868. Carlisle's original meetinghouse was built in 1758 on land donated by Timothy Wilkins. After that structure was destroyed by lightning in 1810, the building pictured here was built in 1811. In 1852, in response to requests from the Ladies Union, the sanctuary was moved to the second floor in order to make the first floor available for other purposes. In 1853, the name Union Hall (honoring the Ladies Union perhaps) was used for the first time. In 1868, the present-day spire replaced the one pictured.

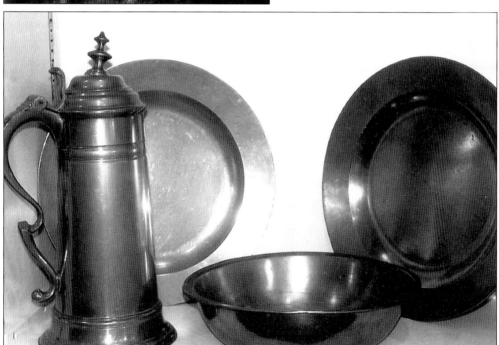

PEWTER CHRISTENING BOWL AND COMMUNION SET. This mid-18th-century set (including two flagons, two plates, and six beakers) was first used by Rev. Paul Litchfield. The set was loaned by the church to the Carlisle Historical Society for many years. Today, the set is back at the First Religious Society, where it is used for child dedications and Communion services.

Rev. B. F. Summerbell. B. F. Summerbell served the First Religious Society in 1864 and 1865. Rev. Paul Litchfield, the town's first settled minister, served from 1781 until his death in 1827. He was loved and respected by his parishioners. Not until 1870, under Summerbell's successor, Rev. John S. Smith, was there any official association by the First Religious Society with the American Unitarian Association.

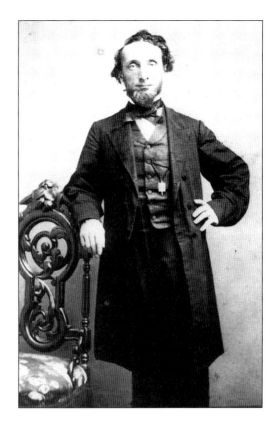

The Laymen's League. This men's organization of the First Religious Society began in the 1920s and did not disband until the 1960s. It met monthly and had a diverse range of activities—whist parties, dances, ladies nights, ball games with the Brotherhood of the Congregational Church, talks on the preservation of roadside trees or the duties of a county commissioner, and even a pool-playing session with members of the Acton Fire Department.

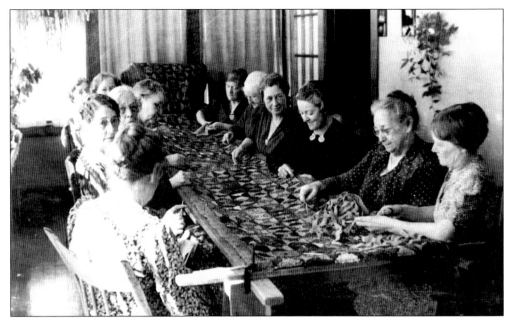

WOMEN'S ALLIANCE OF THE FIRST RELIGIOUS SOCIETY. In 1914, the Carlisle Alliance Branch was formed. It disbanded in the mid-1970s. For eight months in 1939 and 1940, the group held all-day Tuesday meetings to hook a rug for the stairs and platforms leading to the sanctuary. Pictured around the table are, from left to right, Caroline Hill, Winifred Nobles, Carrie Bates, Alice Hill, Sara Tuttle, Mary Stearns, Emma Lapham, Sara Ricker, Harriet Patch, Beulah Kemp, Nettie Wilson, and Mary Lapham.

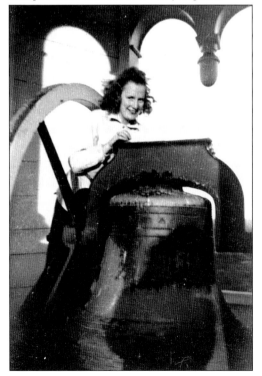

BELFRY AT FIRST RELIGIOUS SOCIETY, 1942. Frances Lapham (pictured) took photographs from the church belfry that appear elsewhere in this book. Edmund L. French's 1914 photograph at the beginning of this chapter was also taken from this spot. Joanna Gleason made two gifts for the installation and maintenance of a town clock in the steeple. The tower clock by the E. Howard Clock Company was installed in 1895 and is still in use today, although the clock faces were replaced in 1977.

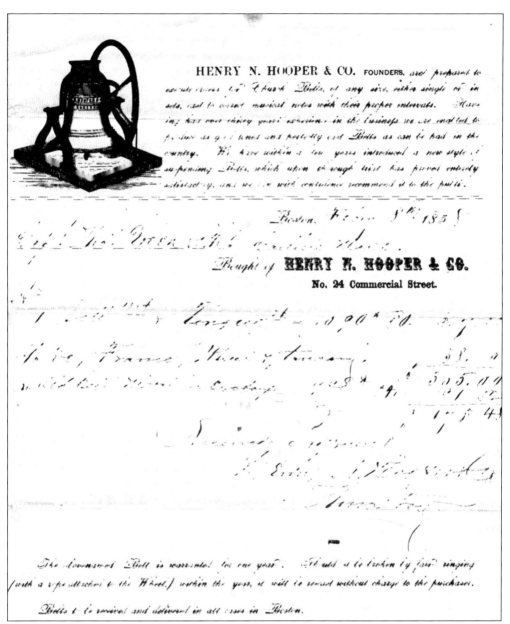

BELL BILL. In 1812, a Paul Revere bell was installed in the First Religious Society steeple. After it cracked in 1857, a new bell made by Henry N. Hooper and Company was installed in 1858. That bell is still in use today and is pictured on the previous page. It is rung automatically each hour, but on special occasions, it can also be rung by a rope that hangs in the area in back of the sanctuary.

EARLY MASS IN CARLISLE. In the spring of 1946, after a meeting at his home, Albert Belanger approached Rev. Michael Burke at St. Bernard's Church in Concord to discuss holding Catholic services in Carlisle. Rev. Mark Sullivan (far left), curate at St. Bernard's, became the new mission church's inspirational leader. On July 7, 1946, Burke officiated at the first mass, held outdoors at James and Celia Barron's home at 91 Westford Street.

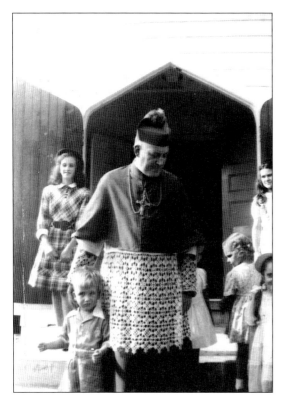

ARCHBISHOP CUSHING AT ST. ELIZABETH DEDICATION. More than 300 people attended this September 13, 1947, event, where Archbishop Richard J. Cushing officiated. He stands with Tommy Gallagher, the son of Edna and James Gallagher, who were very active in the establishment of the mission church. Edna Gallagher maintained a church scrapbook, now at the rectory, until she and her husband moved to Cape Cod in 1973. James Barron was chairman of the dedication committee.

MASS CELEBRATED IN BARRONS' GARAGE. When the weather grew bad, services moved to the garage. In this c. 1946–1947 photograph, Rev. Mark Sullivan is officiating at a service held in the garage. James Gallagher had already built the first altar and tabernacle for such occasions. The altar rail, altar drape, benches, and confessional were donated by Hanscom Field, where a chapel was being rebuilt and where Gallagher served as the fire chief.

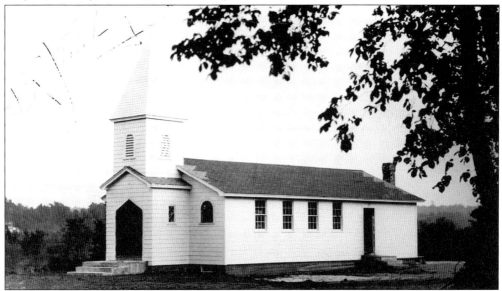

ST. ELIZABETH CHAPEL DEDICATION, 1947. The building was originally a canteen moved from the World War II Maynard-Sudbury ammunition depot to 72 Bedford Road. The chapel was named in memory of Celia Barron's mother and in appreciation to the Barron family for the use of their property for services and activities. This dedication photograph was signed by Archbishop Richard J. Cushing. In 1960, St. Elizabeth Mission became the Parish of St. Irene.

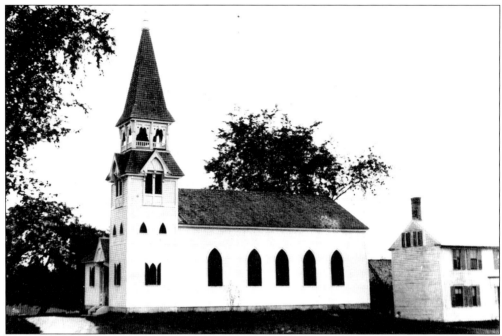

CONGREGATIONAL CHURCH. This photograph shows how the church appeared from 1882 to 1905. Following the 1827 death of Rev. Paul Litchfield, who had served the town for 46 years, there was a divided vote over naming his successor. In an era of growing liberality and freedom of choice, a group left the meetinghouse to form the Union Calvinistic Society. In 1903, the church was incorporated, and the congregation changed its name legally to the Carlisle Congregational Church.

LADIES CIRCLE PICNIC. The Ladies Circle of the Congregational church enjoy an outing to Ashby on July 29, 1937. From left to right are the following: (first row) Alice French (in shadow), Emma Dutton, Mabel Hastings, Sarah Davis, Winifred Lee, Marie Moran, and Emily Garthe; (second row) Mary Stearns, Louise Currier, Sarah Prescott, Sarah Tuttle, Anna Barrett, and Mary Green.

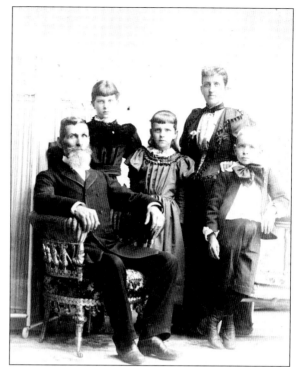

REV. JOSEPH HAMMOND AND FAMILY, C. 1890. Joseph Hammond was pastor of the Union Calvinistic Society from 1889 to 1894. The Christian Endeavor Society was formed at the church during his ministry. He and his family lived in the church parsonage at 55 Lowell Road. His wife organized a women's missionary society and was president of the Sunday school and the Ladies Circle.

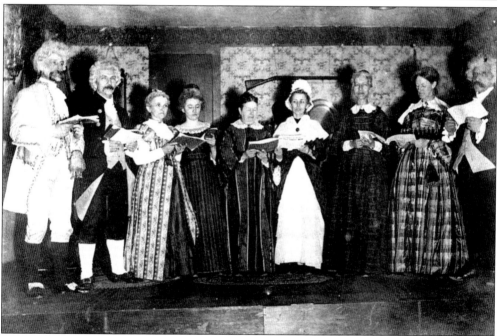

THE "OLD FOLKS" CONCERT, 1911. Members of both town churches participated in a "supper of old time viands" and a concert with singers in "striking costumes of former days" at the First Religious Society to raise funds for an addition to the Congregational church. During the late 1800s and the early decades of the 1900s, the two churches worked, socialized, and held special services together.

QUARTERLY MEETING

THE

Middlesex North-West Temperance Union

WILL HOLD ITS NEXT MEETING IN THE

CONGREGATIONAL CHURCH

...CARLISLE...

THURSDAY, OCT. 10, 1901

ORDER OF EXERCISES.

9.30 A. M.	Devotional Exercises led by the pastor, Rev. Mr. Armes.
9.45 A. M.	Reports from Towns.
10.15 A. M.	Topic for the morning: "Is there a Practical Method by which the Pecuniary Profit can be Eliminated from the Liquor Traffic?" To be opened by Rev. Frank B. McAllister of Bedford. Followed by discussion.
11.00 A. M.	Historical Address* by Abram English Brown of Bedford.
12.00 M.	Appointment of Committees. Adjournment.
1.30 P. M.	Report of Committees.
2.00 P. M.	Address by Rev. William C. Martyn of Boxboro. Subject to be announced.
	Discussion.
	Adjournment.

*This Union has existed Thirty-nine Years, its Fortieth Anniversary occurring next June.

The Union comprises the following Towns: Acton, Ashby, Ayer, Bedford, Boxboro' Carlisle, Concord, Dunstable, Groton, Littleton, Maynard, Pepperell, Shirley, Stow, Townsend and Westford.

The Vice-Presidents are requested to see that some one is prepared to report for their respective Towns.

Clergymen are requested to give notice of this Meeting from their Pulpits.

Free conveyance will be given from the Carlisle Station on arrival of the morning train at 8.16 a. m.; also, from the Electric Street Railway Waiting-room at Bedford at about 9 o'clock a. m., and return.

REV. W. J. BATT, President.
CLARA H. NASH, Secretary.

HUNTLEY S. TURNER, POWER PRINTER, AYER, MASS

TEMPERANCE UNION MEETING, 1901. The temperance issue was first presented to a Carlisle congregation by Rev. George W. Stacey of the First Religious Society. He may have influenced the town meeting vote in 1837 that prevented the selectmen from licensing any taverns or retailers. Since the town frequently used funds for liquor, residents were uncomfortable with the decision, and the next month they voted to reconsider.

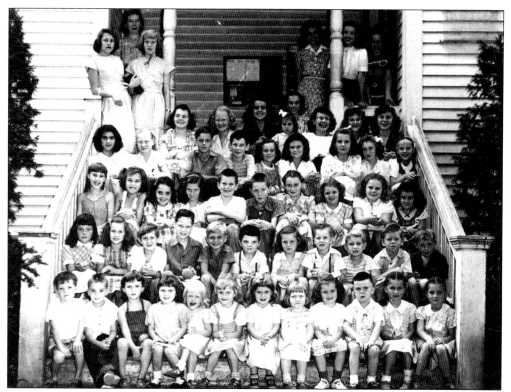

VACATION BIBLE SCHOOL, 1948. All the children of Carlisle were invited to the two-week Bible school sessions each summer. Classes were held at the Congregational church weekdays, from 9 a.m. until 12 noon, with a closing program in the evening of the second Friday. Students learned Bible stories and verses, sang, and did craft work pertaining to the lessons. Mrs. Charles Massey, the minister's wife, directed the 1948 program. The school started c. 1940 and continues today in a different form.

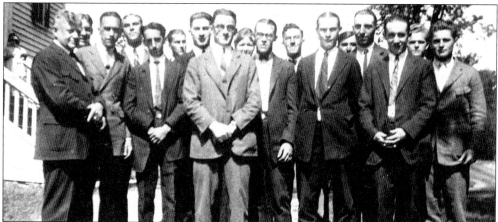

TRUE BLUE CLASS, C. 1930. Sometime before 1925, this men's organization was formed by the Congregational church to promote fellowship and to raise money for the church. The True Blue class met monthly, usually at members' homes, to hear speakers, discuss ways to help the church, and provide for those in need. The members also held work nights at the church, which were an important part of their mission. The last written records of the group are dated 1950.

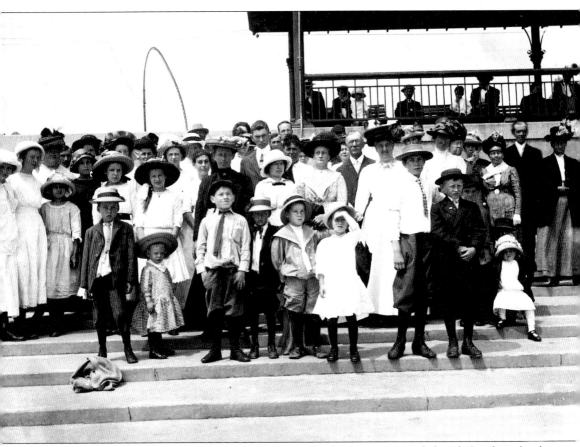

REVERE BEACH OUTING, C. 1913. This photograph of a Congregational church Sunday school outing was taken by the late Edmund L. French, a church member. The families of several of the people pictured still live in Carlisle. From left to right are the following: (first row) Kenneth Duren, Sam Duren, Donald ("Hunk") Davis, Allen Duren, Willard Davis, unidentified, Charles Davis, and unidentified; (second row) Hazel Davis, Mabel Bates, unidentified, Florence Malcolm (dark dress), Ethel Puffer, unidentified, Minnie Duren (dark dress), unidentified, ? Malcolm, unidentified, Winifred Lee, Arthur Lee (in front of his mother, partially hidden), and Helen (Lee) Wilkie, sitting with father Herbert Lee (mostly hidden).

Five
HOMES

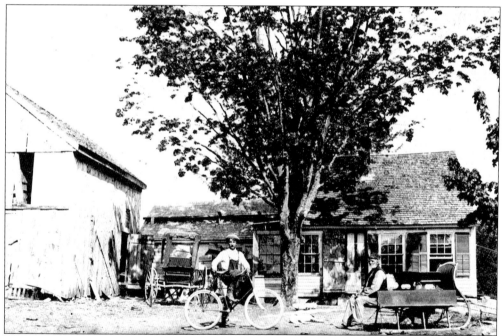

SAMUEL HEALD ROBBINS HOUSE (1354 CURVE STREET). Fred Fern (left) and Samuel Robbins meet at the Robbins House in this 1890 photograph. Samuel Robbins went to California in the gold rush of 1849 and, with the money he made there, built this house in the mid-1800s. Many descendants of George Robbins, who came to Carlisle before 1666, settled in the area of Curve Street when it was still part of Chelmsford.

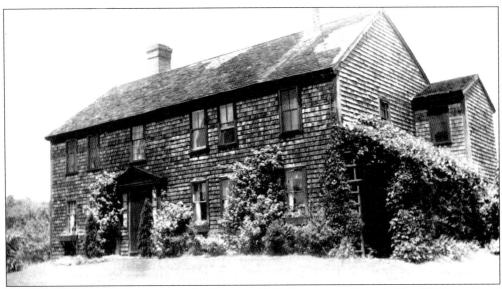

HOME OF REV. AND MRS. BENSON P. WILKINS (245 ROCKLAND ROAD). The Wilkinses lived in this stately home, which began as a primitive dwelling built between 1779 and 1789 by John Jacobs. His son, John Jacobs Jr., was a farmer and mason who did much of the stonework in Carlisle in the mid-1800s. The front stone wall at Green Cemetery, along Bedford Road, is a testament to his skill.

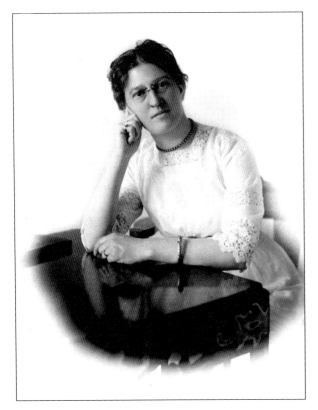

MARTHA WILKINS. In 1936, Martha Fifield Wilkins, wife of Rev. Benson Wilkins, gave a priceless gift to the Gleason Public Library: 25 volumes of photographs of and genealogical background on historic houses in Carlisle that she had compiled. Without this impressive work, much of what we now know about Carlisle families and houses would have been lost. This book relies heavily on Wilkins's work, and we are deeply grateful for her unique contribution to the town.

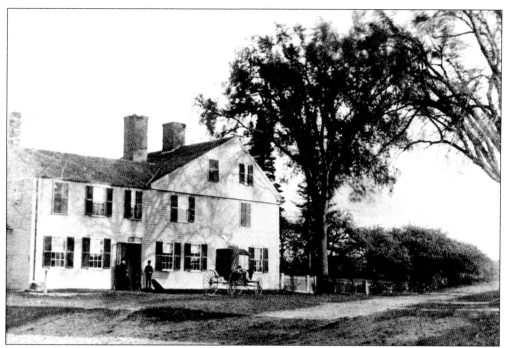

BLOOD-LEE-WOODWARD HOUSE (767 BEDFORD ROAD). Named after Carlisle's earliest settlers, this house was built in 1731 by Stephen Blood. It was a large house in which Elnathan Blood operated a tavern and a store in the late 1700s. In 1834, the house was remodeled, and two barns and a cooper shop were added. Six families have lived here, including the family of former Gleason librarian Helen Lee Wilkie, who was born here in 1910.

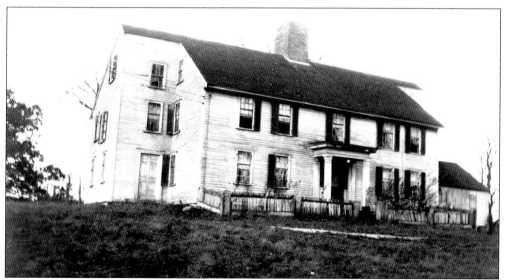

SPAULDING-HART HOUSE (1044 LOWELL STREET). This unique English gable-end house is thought to have been constructed in 1716 and is one of the oldest residences in town. The house contains 19 rooms on various levels and was built of logs with board coverings; this explains the thickness of the outside walls. At least four generations of the Spaulding family lived here for over 100 years.

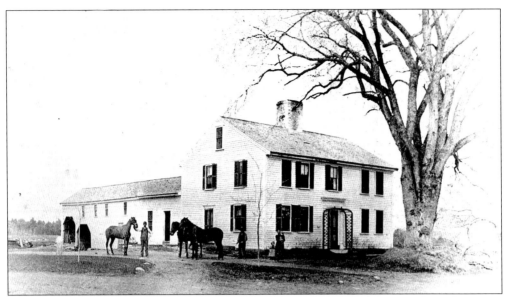

BLOOD-FOSS HOUSE (981 BEDFORD ROAD). This house is the first home on the right as one enters Carlisle from Bedford via the Bedford-Carlisle Bridge over the Concord River. The structure was built by Simon Blood in 1739. In 1904, William Foss Jr. bought the property and operated a productive asparagus farm on several acres that extended down to the Concord River.

JAMES ADAMS HOUSE (45 SOUTH STREET). James Adams, who left Carlisle, England, c. 1640, is considered this town's first settler. At this location on South Street, he built a small gambrel-roofed house (right). It is also known as the Jock House, after Jonathan Heald II's son Jonathan (nicknamed Squire Jock), who lived there with his large family (15 children) in the early 1800s. The house was moved across the street in 1940 and was renovated, but the gambrel roof and center chimney are original.

BRICK-END HOUSE (84 SOUTH STREET). Jonathan Heald built this handsome house c. 1780, and his son, Jonathan Heald Jr., succeeded his father as owner. The house, barn, and surrounding 100 acres that belonged to the Wilson Stock Farm were purchased in 1928 by Dr. Lawrence Lunt, a psychiatrist. Lunt converted the large barn into a private sanitarium that he called Valleyhead; thereafter the entire area around South Street became known as Valleyhead as well. (This vicinity once held copper mines that provided a small but thriving industry for Carlisle from 1840 to 1849.) Lunt used the Brick-End House as his private residence, preserving its beautiful paneling, graceful cornices, and dados while adding modern improvements. Fireplaces that had been bricked over were restored, and original wood that had been painted over was revealed. Today the house has been converted into two apartments, and it still retains its historic beauty.

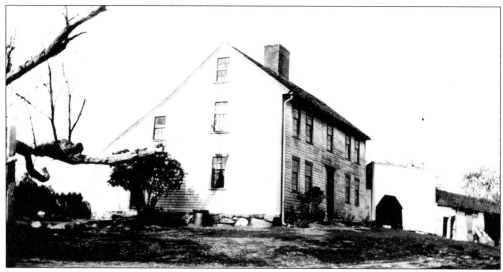

TILLY GREEN-BALDWIN FARMHOUSE (493 BALDWIN ROAD). Tilly Green, son of Nathan and Lois (Conant) Green, built this house in 1811 for his bride, Patty Lane of Bedford. When Henry David Thoreau took his long walks from Concord across the fields and old roads through Carlisle, he would sometimes stop at this house to get a refreshing drink of water from the open well.

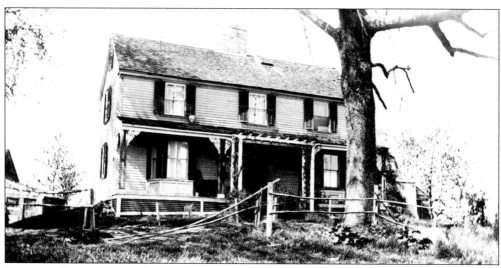

ZACHEUS GREEN HOUSE (211 BELLOWS HILL ROAD). The large Green family owned many houses in town; this is one of the earliest. This house dates from 1765 and was built by Zacheus Green, son of John Green, an early settler. The house originally had only two rooms, one on top of the other, and further additions were made over the years. Green was a Revolutionary soldier and served as selectman in 1782.

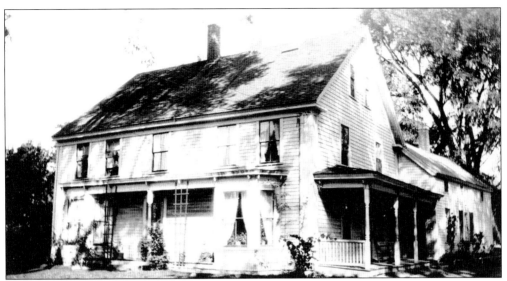

SAMUEL HEALD HOUSE (698 CONCORD STREET). Although it cannot be confirmed, the original house at this location was probably built c. 1740 by Samuel Heald. In 1784, the home suffered a disastrous fire. Samuel tried to rescue his son from the blaze, but both father and son perished. In 1788, Samuel's son Capt. Samuel Heald Jr. built another house on the site. Today the Capt. Samuel Heald House is the home of the Carlisle Historical Society.

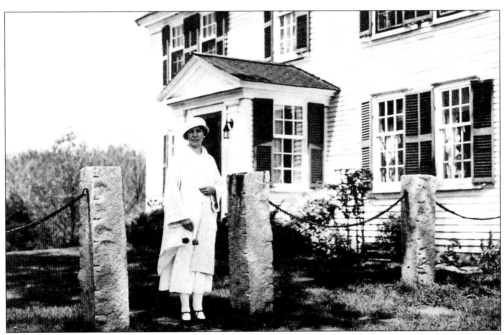

THE LITCHFIELD HOUSE (501 LOWELL ROAD). Jennie Fisk stands outside her home in the 1930s. Often called the Litchfield Parsonage, it housed Carlisle's first minister, Rev. Paul Litchfield. A 1775 Harvard College graduate, Litchfield became the minister of the newly formed church of 30 members in 1781. After 46 years as Carlisle's much loved minister, Litchfield died in 1827 and was laid to rest in the Central Burying Ground.

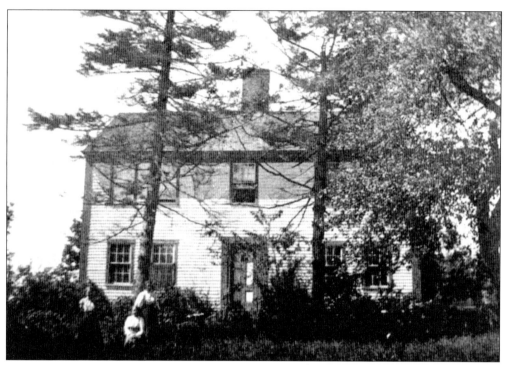

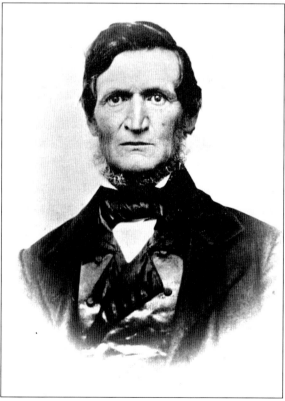

STEPHEN TAYLOR HOMESTEAD (WORMWOOD HILL, CROSS STREET). This house was built in 1790 or 1791 by Benjamin Foster, and in 1834 it was sold to brothers Nathaniel and Stephen Taylor. In 1835, Stephen became the sole owner, and that same year, he married Emeline Parker, a schoolteacher. Stephen's portrait appears at the left. An interesting artifact from the Stephen Taylor House is a framed, printed copy of the first prayer ever offered in the U.S. Congress, dating from 1777. The document is now owned by the Lapham family, descendants of Emeline Parker Taylor. The Taylor Homestead is no longer standing.

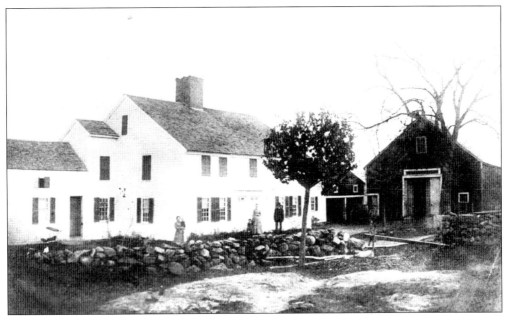

NICKLES HOMESTEAD (1019 NORTH ROAD). This house, built c. 1779, when the area was still Billerica, stayed in the hands of the Nickles family well into the 20th century. The homestead originally provided for two households. Although there is a central chimney, the structure has two separate brick ovens. The interior door decorations and panels are very plain, and the house design is functional, pointing to the frugal nature of the early owners.

ANDREWS-GREENOUGH FARM (528 MAPLE STREET). Solomon Andrews came to Carlisle from Ipswich c. 1757. He and his sons farmed here and built one of Carlisle's six mills. The house pictured here was built c. 1830 by Thomas Page, who farmed and operated a gristmill. Part of the flat meadow was used as a training field for Revolutionary War soldiers. Today, the property known as Greenough Farm is conservation land with extensive hiking trails.

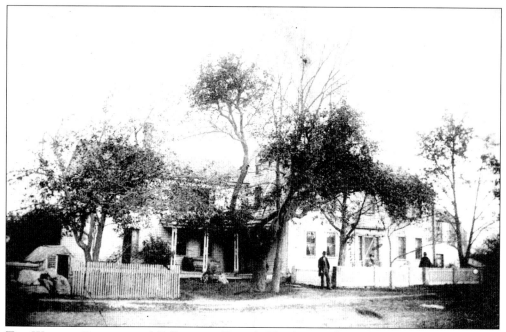

THE WILKINS HOMESTEAD (43 BEDFORD ROAD). This historic house has watched over Carlisle Center since 1789. It stands on land included in the first Timothy Wilkins Farm of 112 acres, which covered the large area of Carlisle Center that was once Blood Farms. In 1921, James Harry Wilkins, a widower and one of Carlisle's esteemed citizens, moved here with his children. In 1923, he married Ruth Chamberlin, daughter of storekeeper Daniel Lang Chamberlin.

RUTH CHAMBERLIN WILKINS. Ruth Chamberlin Wilkins was born and raised in the Daniel Lang Chamberlin house. She was a meticulous chronicler of Carlisle life and served as town clerk for 22 years. Wilkins was extremely active in many town affairs and was a founder of the Carlisle Historical Society, but her greatest legacy is her book *Carlisle: Its History and Heritage* (1976).

Dr. Austin Marsh. Born in 1811 in Sharon, Vermont, Dr. Austin Marsh was one of nine children and the youngest of seven boys. He graduated from Dartmouth Medical College in 1835 and came to Carlisle in 1838. In 1839, he married Mary W. Skelton of Pelham, New Hampshire. Marsh was Carlisle's physician for 60 years and was also a selectman, town clerk, and school committee member. He died in 1900 and is buried in Green Cemetery, as is his wife, Mary.

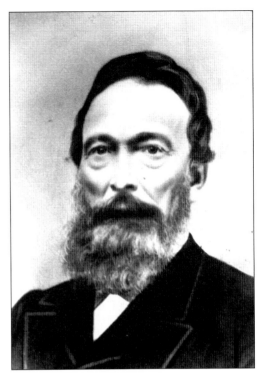

Home of Dr. Austin Marsh (46 Lowell Street). In 1879, after 40 years of marriage, Dr. Austin Marsh built this house, where he and his family lived and he kept his medical practice. The residence was considered quite grand for that time; it was designed with Victorian gingerbread and other ornamentation that made the house a bit overpowering compared to the simpler, smaller homes in the area.

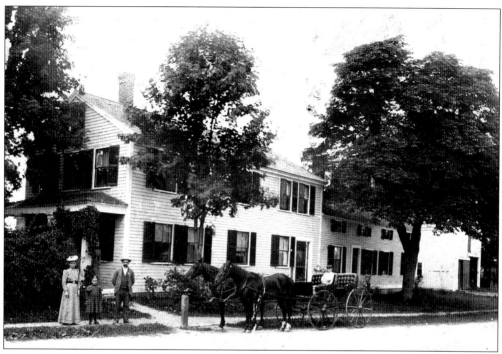

DANIEL LANG CHAMBERLIN HOUSE (9 LOWELL ROAD). The Chamberlin family is pictured outside their home, which was built between 1829 and 1830 by William Green II. In 1885, the Chamberlins moved to Carlisle from Bath, New Hampshire. Daniel Chamberlin, known as Lang, was a longtime store owner in town, and from 1898 to 1940, he served as postmaster. The post office was located in his store in Carlisle Center.

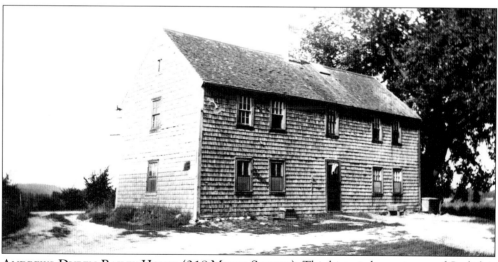

ANDREWS-DUREN-BAILEY HOUSE (318 MAPLE STREET). This historic house is one of Carlisle's oldest. It was constructed c. 1687 by Josiah Blood, son of Robert Blood, who was one of Carlisle's earliest settlers. Initially, the house was half its present size and featured a brick wall to provide protection against Native Americans. The brick wall was later covered by new construction.

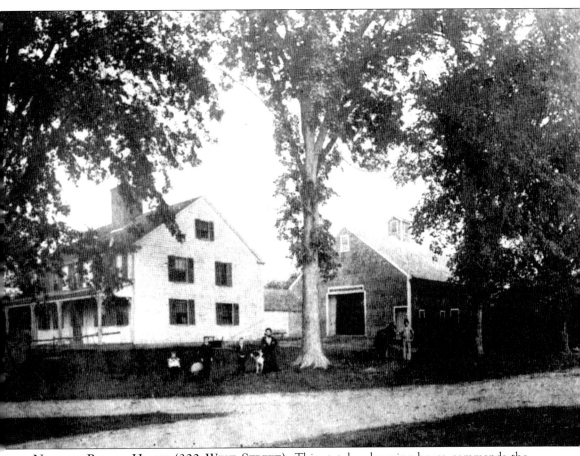

NATHAN PARLIN HOUSE (322 WEST STREET). This stately, charming house commands the "Four Corners" at the intersection of Acton and West Streets. When it was built in 1721 by Josiah Heald, the house was located in Acton, but the property later became part of Carlisle when town boundaries were redefined. Nathan Parlin inherited the house in 1770 from his father, Jonathan, and subsequently made additions and changes to the house. Nathan Parlin was a Minuteman from Carlisle during the Revolutionary War, and he served as a selectman in 1784. Over the years, the Parlin house has been transformed from a saltbox-type structure to a Colonial-style house, with large square rooms whose ceilings are crossed by summer beams and whose fireplace walls are wood paneled. The extensive lawns, woods, and gardens that complement the handsome house and barn today make this one of Carlisle's most beautiful properties.

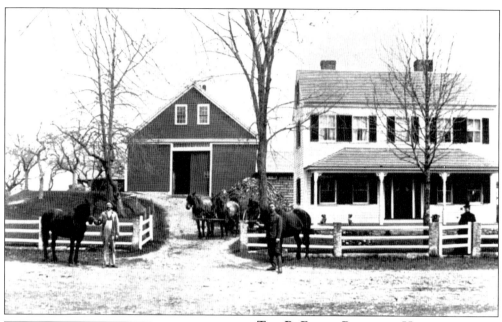

THE B. FRANK BLAISDELL HOME (70 LOWELL STREET). It is thought that Luther Twitchell built this home *c.* 1835, but confirmation of this fact has been difficult. It is known that the property belonged to only one family—the Blaisdells—for about 133 years. The current owners bought the house in 1968 and are still in residence. In 1897, owner Benjamin Frank Blaisdell (seen to the left) raised the ell, allowing for more rooms to be built, and added on a Victorian porch (then called a piazza). Since that time, the house has been "unspoiled" by additions or renovations, according to the current owners.

EDWARD E. LAPHAM. In the 1920s, Edward E. Lapham was one of only two Carlisle Civil War veterans who marched in the Memorial Day parade (Daniel Webster Robbins was the other), and he carried the Grand Army of the Republic flag. In 1904, Lapham was one of three overseers of the Town Farm.

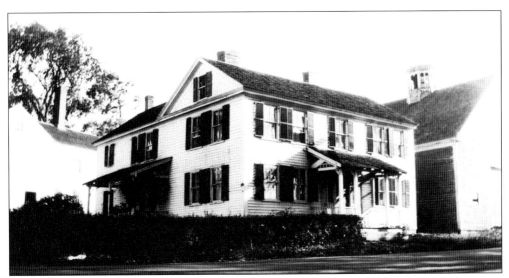

NUTTING-LAPHAM HOUSE (49 CONCORD STREET). The origins of this house are obscure; it might have been built by Asa Nutting before 1850. From 1888 to 1893, one downstairs room was used as the town library, which was directed by Mary Green and her husband, Thomas. In 1903, Edward E. Lapham bought the house and lived upstairs, while his son, Arthur T. Lapham, and his family lived downstairs.

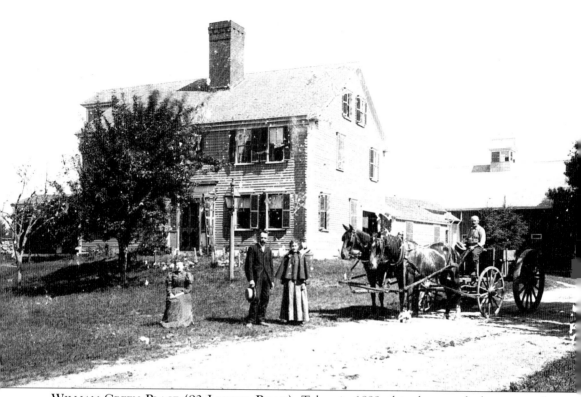

WILLIAM GREEN PLACE (93 LOWELL ROAD). Taken in 1899, this photograph shows one of the few old houses that face south in Carlisle Center. The house was built in 1792 by William Green's father, Nathan Green Jr., who in 1789 was co-owner with Daniel Wheat of a small store next to the Wheat Tavern in the center of town. William was one of seven Green children, and he lived in this home until his death. He was one of three residents appointed by the town in 1858 to assess property at the Town Farm, the first such appointment made. William Green made several changes to his family's home—raising the roof and adding new rooms and an attic. A generous man, he gave the town the land for the Red Brick School in 1848 and donated the tree from which the first flagstaff for the town common was made.

Six
COMMUNITY LIFE

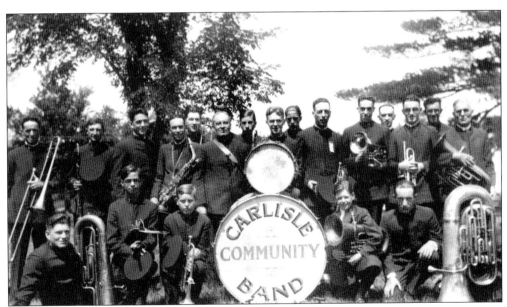

CARLISLE COMMUNITY BAND, 1926. Music, theater productions, the Grange, dances, parties, the churches, and sports all contributed to the community life of Carlisle. Members of the Community Band are, from left to right, as follows: (first row) Gordon McAllister, Rudolph Currier, Henry Helsher, Gordon Westby, and Norman Davis; (second row) Roy Butler, Joseph Girard, William Wilkie, Donald Davis, ? Howe, Wilbur Malcolm, Donald Lapham, Laurence Gray, Walter Goss (director), Clifford Farley, Fred Nickles, Arthur Lee, Onslow Dutton, and R. McAllister.

RECEIPTS AND EXPENDITURES OF THE
TOWN OF CARLISLE,
FROM APRIL 1ST, 1847, TO APRIL 1ST, 1848.

EXPENSES.

James W. Wilkins, Postage bill, 1846,	$1 46
Jonas Parker, abatement of taxes assessed in 1845,	4 50
George F. Duran, abatement of taxes for 1846, as follows :	
John Blanchard, $1 50	
Charles Blood, 1 16	
John Dexter, 1 50	
Willard Duran, 1 50	
John O. Densmore, 1 50	
Zenas H. Dunbar, 1 50	
Robert Gilgrist, 1 50	
Luther Hodgeman, 1 50	
David Litchfield, 1 50	
Abel Nickles, 1846, 45	
Jobe Nickoles, 1845, 1 95	
Seth Wheeler, 1 50	
Andrew J. Wilkins, 1 50	
Samuel Lovejoy, 1 50	
George Mason, 1847, 1 50	
	$21 50
B. F. Heald, for supporting Poor one quarter, ending April 6th, 1847,	78 50
A Parker, for ringing bell, 1846,	12 00
" Postage bill, 1847,	1 00
Benjamin Barrett, printing Report of Expenses, last year,	7 00
B. F. Heald, for labor at the grave yard,	8 49
" keeping the Poor, 1 year, ending April 6th, 1848,	192 00
William Greene, 2d., for interest on the School Fund,	30 00
H. W. Blaisdell, for blank book,	1 50
Lucius Stiles, for 1000 feet Plank,	13 00
" for teaming the same,	3 50
Jonas Parker, for stone,	3 00
" for work on highway,	3 31
A. G. Hodgeman, for making gate to Pound,	3 00
Amount carried up,	$683 76

Amount brought up,	$683 76
Martin Jacobs, for mowing brush in the grave yard,	1 50
Asa Duran, for building road,	50 00
William Pettingille, for digging up trees on the New Road,	40 00
Wm. Greene, 2d., for work on highway,	4 75
Thomas Heald, do. do.	4 44
William Wilkins, do. do.	1 88
George F. Duran, for collecting taxes, in 1846,	31 64
" copying warrants,	75
Abel Taylor, Jr., for mowing on the pound,	1 25
James W. Wilkins, for stone post for the pound,	1 20
Philo Litchfield, Cash paid for a cow,	8 00
John Taylor, for surveying road,	3 50
Nickles & Holland, Road damage,	6 00
Samuel Hoar, Esq., advice on road,	3 00
John Jacobs,	
Cash for sundry bills,	8 44
2 days laying out Roads, 2 00	
½ day going to Concord, 50	
7 ½ days making taxes, 7 50	
Boarding Assessors, 1 50	
Services as Overseer of Poor, 1 00	
2 ½ days letting out roads, 2 50	
Repairing pound, 3 00	
Recording Births, 1 68	
Services at Town Clerk, 10 00	
	32 68
Mrs. I. G. H. Wheat, to use of Hall and entertainment of the Selectmen and Committees,	17 75
Thomas Greene,	
2 ½ days laying out road, 2 50	
1 ½ days letting out road, 1 50	
6 ½ days making taxes, 6 50	
Services as Overseer of Poor 1 00	
" as Town Treasurer, 6 00	
	17 50
Amount carried up,	$917 74

Amount brought up,	$917 74
Lucius Stiles,	
5 ½ days making taxes, 5 50	
2 ½ days laying out roads, 2 50	
Services as Overseer of Poor, 1 00	
	9 00
Calvin Heald, Esq.,	
Services as School Committee,	10 00
Benjamin P. Hutchins,	
Services as School Committee,	10 00
B. F. Heald,	
Services as School Committee,	10 00
Cash paid at Boston, for Joseph Wheeler,	5 00
" Concord, for publishing Report of Town Expenses, &c.,	6 50
Paul G. Firbush, bill for bridge,	1 10
	$969 74
Paid for County Tax,	234 20
	$1203 91

RECEIPTS.

Balance in Treasury, April 1st, 1847,	$216 82
Amount of Taxes,	1104 63
Received for support of Chas. Duran,	2 87
	$1324 32
Balance in Treasury, April 1st, 1848,	$127 ½
	$1321 39

JOHN JACOBS. } Selectmen
THOMAS GREEN. } of
LUCIUS STILES. } Carlisle

CARLISLE, April 3d, 1848.

We hereby certify that we have examined the foregoing statement of Expenses, and find the same correctly cast and properly vouched.

B. F. HEALD, } Auditors.
CALVIN HEALD, }
WILLIAM GREEN, }

School Receipts and Expenditures.

Money's Received. Paid Out.

No. of District	In the Treas.	Town Grants.	Town Fund.	State Fund.	Total.	Summer School.	Winter School.	Total.	Bal. in Treasury
No. 1.	$15 27	$100 00	$6 00	$8 13	$129 40	$21 27	$89 30	$110 57	$18 83
" 2.	30 06	100 00	6 00	8 13	144 19	35 62	72 96	108 58	35 61
" 3.	40 77	100 00	6 00	8 13	154 90	40 00	65 16	105 16	49 74
" 4.	45 00	100 00	6 00	8 13	159 13	51 00	59 48	110 48	18 65
" 5.	27 22	100 00	6 00	8 13	141 35	30 00	88 93	118 93	22 42
	$158 32	$500 00	$30 00	$40 65	$728 97	$177 89	$405 83	$583 72	$145 25

D. H. ADAMS, BOOK, JOB AND CARD PRINTER, CONCORD, MASS.

TOWN FINANCIAL REPORT, 1848. This is thought to be the first printed annual report that town officials authorized. Total expenditures between April 1, 1847, and April 1, 1848, were $1,203.91, excluding school costs of $583.72. Income from taxes for the general funds were $1,104.63. Grants and funding from the town and state for schools totaled $570.65. Note that the schools ran two sessions: winter and summer. A man usually taught the winter session, a time when more older boys attended school. (In the summer, these young men were needed for work on the farm.) A woman taught the summer session, since it was thought that discipline would be less of a problem with the boys off working on the farms. The woman's hourly pay could be half that of the male teacher. Note the family names that recur throughout the history of Carlisle, including Heald, Green, Hodgman, Blaisdell, Wilkins, and Parker.

JUNIOR RED CROSS WORKERS, C. 1918. During World War I, Mrs. Benson P. Wilkins organized this group, which met every Saturday afternoon for two hours. The members of the Junior Red Cross made layettes for infant refugees, crutch pads, gun wipes, eye dressings, and bed socks for the servicemen. In addition, they collected secondhand garments, cloth for windproof vest linings, money to support the Red Cross, and nine and a half pounds of tin foil. The group also sent out 268 postcards and 25 valentines.

SQUAD 3, TROOP F CAVALRY, C. 1900. Troop F volunteers were organized in 1864 and disbanded in 1907. The unit served New England and New York State. From 1880 until 1907, the troop met first in buildings at the corner of Lowell and Bedford Streets and later gathered in Union Hall. A highlight of the year was the week in June spent training on the muster field in Framingham, where this photograph was taken.

SPALDING PARK BASEBALL TEAM, 1932. Squad members are, from left to right, as follows: (first row) Herbert Lee, Norman Davis, Norman Malcolm, Dick Bates, Frank Biggi, and Willard Davis; (second row) Kenneth Duren, Guy Clark, Sam Duren, Arthur Hall, Palmer Pedersen, John Hart, and Allister MacDougall.

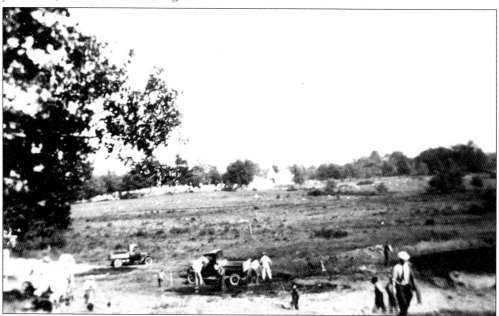

CONSTRUCTION OF SPALDING PARK, C. 1926. In 1923, a committee was appointed to look into the possibility of purchasing land on School and Church Streets to be used as a public park. As it turns out, the owner of the property, Oscar Spalding of Westford, was happy to donate the land to the town. Volunteer work parties were held over the next several years, and the grand opening of the park and baseball field was held on May 7, 1932.

GRANGE OFFICER INSTALLATION CEREMONY, C. 1943. Originally an association of farmers, the Grange's interests grew to include not only farm life but also family and community life. The group sponsored lectures, discussions (including one on women's suffrage in 1909), musicals, dramatic productions, and children's nights. The Grange was also involved in town projects, such as landscaping the area around the Highland School in 1912 and erecting the town honor roll in 1945.

THE GRANGE. The first Carlisle Grange, No. 258, was instituted in 1906 and met in Union Hall twice a month from September through May. Grange No. 258 disbanded after 1914. In 1937, Grange No. 402 was organized. Meetings were held at Brick School, Union Hall, or the Cranberry Bog House. Rena Clark gave land on Concord Street for a new Grange hall, which was dedicated in 1953. This group disbanded c. 1970, and the Grange building was transformed to the residence at 522 Concord Street.

MACARLO CHORAL SOCIETY. Pictured are society members Priscilla Currier (left) and Frances Lapham, dressed for a 1942 concert. The group numbered between 18 and 20 members and included people from surrounding towns. Performances were held throughout the area in the late 1930s and early 1940s. Practices were held at the Cranberry Bog House, where there was a piano.

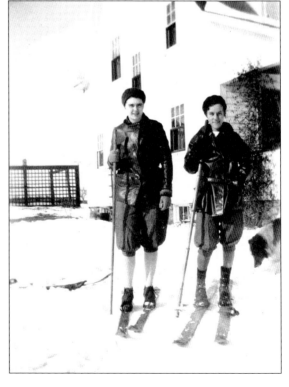

SKIERS. Before their marriages, Esther (Wilkins) Anderson (left) of 43 Bedford Road and Helen (Lee) Wilkie of 129 East Street are pictured with their ski equipment and garb in the late 1920s. They are standing by the Wilkie home, where Helen lived from 1925 until her death in 1998 (except for a few years early in her marriage).

DANCES. In the 19th century, dances were held at a few locations in town: Mrs. Wheat's Hall in the Wheat Tavern; Parker's Hall, on the second floor of the building owned by Artemas Parker on the corner of Lowell Street and Bedford Road; and, after building changes in 1853, at Union Hall. People from surrounding towns also attended these events. The dances were known to go on into the early-morning hours.

SIR—

Your company with Ladies is respectfully solicited at the Hall of

MESSRS. FLETCHER & BLOOD,

IN CARLISLE, ON

WEDNESDAY EVENING,

MAY 29th, 1844.

Dancing to Commence at Five o'clock. Tickets, including Supper, $1.50.—Music, by W. Buttrick & S. Haynes.

STILLMAN HEALD, } Managers, { GILMAN NICKLES.
A. G. HODGMAN,

Carlisle, May 12, 1844. Freeman Print.

SOCIAL BALL, 1844. As this invitation shows, the social event on May 29, 1844, included dancing and dining, all for a ticket price of $1.50. The location of the hall of "Messrs. Fletcher and Blood" is not known. (Both families owned a great deal of property in Carlisle.) Dances of the day included the "Virginia Reel" and "Lady Washington's Reel" (both contras), the quadrilles "Laugh and Grow Fat" and "Home, Sweet Home," as well as waltzes, polkas, and schottisches.

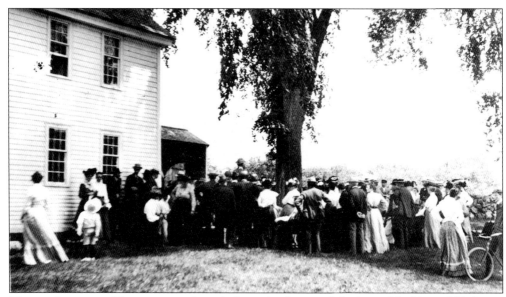

HEALD AUCTION. The auction of goods from the home of Ambrose Heald, at 566 Acton Street, drew a large crowd of antique collectors on July 3, 1903. Ambrose was the sixth generation of Healds to live in the home, which was built *c.* 1712. Some of the furnishings that were up for bid dated back to the time of the home's original construction. The auction was an event of such importance that it was covered in the *Boston Daily Globe*.

PARTY WITH SERVICEMEN. During World War II, servicemen stationed at Hanscom Field in Bedford came to Carlisle for social events. In June 1943, the group pictured had a weenie roast at Milnes' Camp on Maple Street. William and Lorna Milne, then of Lexington, owned 60 acres and put a cabin and outdoor fireplace on the property. The area was used by townspeople for ice-skating, picnics, and trail walks.

CARLISLE'S FIRST BOY SCOUT TROOP, 1947. The Scouts of Troop 36 are, from left to right, as follows: (first row) Randolph Foss, H. Smith, Bill MacDonald, and Bruce Whitman; (second row) Alfred House Jr., Roger Davis, Norman (Buddy) Davis, Carl Andreassen, Calvin Hayes, Walter Otterson, Bob Daisy, and Frank Marrier; (third row) Arthur Gates, Murray Bruce, Bill Clark, Murray Heald, Robert Spooner, Richard Lamburn, and Dan Fulton. The adults who organized the troop are, from left to right, Scoutmaster Alfred House Sr., David Bott, George Foss, Henry Lamburn, Karl Spooner, Stanley Wright, Philip White, Edwin Storer, unidentified, and Harold Smith. Richard Lamburn, now of Westford, remembers that the troop met twice a month in the Brick School. Knot tying, no-matches campfire lighting, and tent camping were among the activities. Bob Daisy, now of Concord, recalls that the troop "camped with the cows" in the field in back of 1019 North Road. Yearly jamborees were held in Concord. Troop 36 remained in existence until 1963. Troop 135 was established in 1964 and is thriving today.

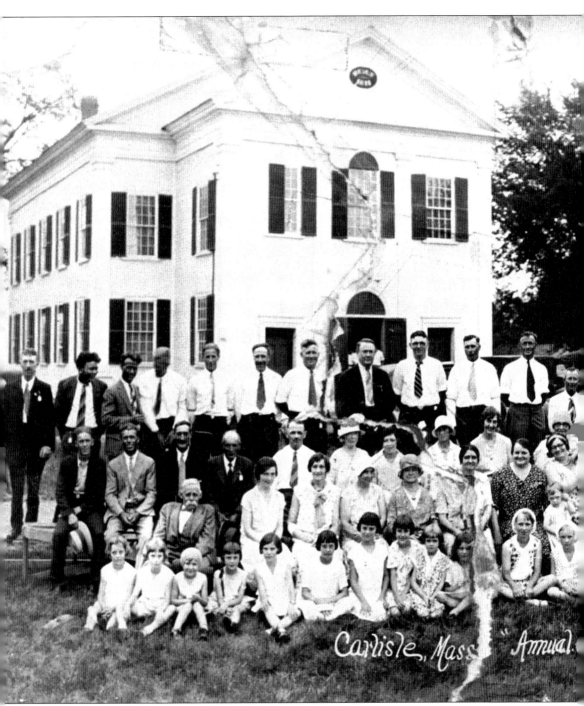

SCANDINAVIAN CLUB. Young families who had come to Carlisle early in the 1900s from the Scandinavian countries are gathered in front of the First Religious Society on July 13, 1930. Displayed above the group, on the right, are the flags of Norway (left) and Sweden. As is typical of most immigrant populations, the Scandinavians socialized among themselves and kept the customs that they or their parents had observed back home. When the Scandinavians arrived

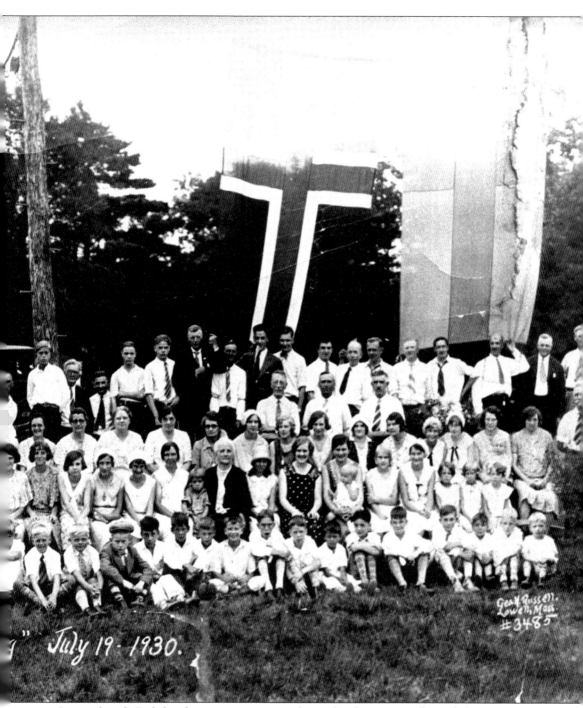

July 19-1930.

in Concord and Carlisle, the men went to work on the farms, regardless of their previous occupations. Often their wives were employed as maids or cooks. Eventually, through hard work and frugality, the Scandinavian farmers were able to buy their own land and become active members of the Carlisle community. They worshiped in one of two Scandinavian churches in Concord and enjoyed dances held at the Cranberry Bog House.

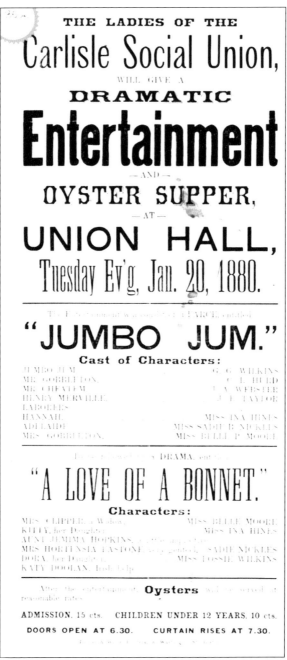

THEATER. Local talent performed in concerts, charades, and plays in the late 1800s. People from surrounding towns attended the events. In the winter, the attendees' horses were stabled at Gilman Nickles's barn on Westford Road. Traveling entertainers came to town, too. Those acts included singer and dancer Comical Brown; "Dr. Soloman and His Kickapoo Indians," who advertised Soloman's patent medicine and offered free tooth extractions on stage; a group of glassblowers; and "Kimball's Cyclorama or a Trip Around the World." The playbill pictured advertises a January 1880 offering from the Ladies of the Carlisle Social Union; the evening's entertainment included two plays (a farce and a drama) and an oyster supper.

Seven
CELEBRATIONS

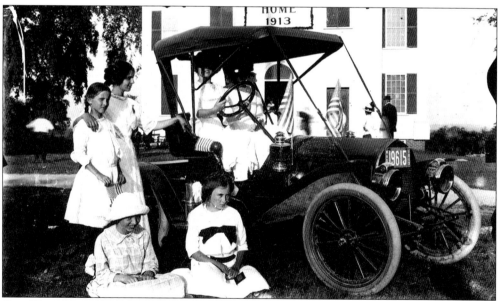

OLD HOME DAY, 1913. On August 12, 1913, Carlisle residents celebrated the second annual Old Home Day. A morning parade included automobiles and bicycles decorated for the occasion. Pictured here is the well-known Metz car owned by photographer Edmund L. French. At the wheel is Isabel Petrie; standing by the car are Edna Schoolcraft (Sleeper), left, and May Currier; and sitting are Ruth Chamberlin (Wilkins Hollis), left, and Florence Malcolm.

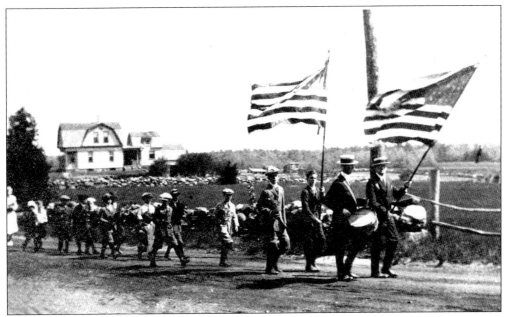

MEMORIAL DAY PARADE. The parade marches down Bedford Road toward Green Cemetery. Note the open fields on Bedford Road behind the parade group. In 1909, the town purchased a silk flag to be carried annually in the Memorial Day procession.

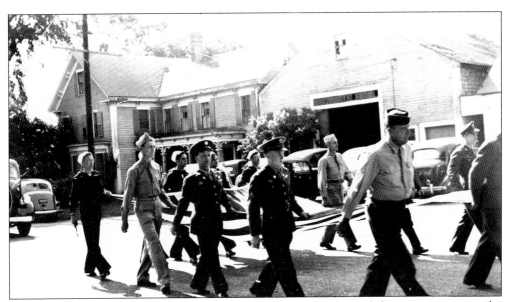

MEMORIAL DAY COLORS. In this World War II–era photograph, Carlisle servicemen carry the flag through the center of town during the Memorial Day parade.

LAST CIVIL WAR VETERANS. Carlisle's last Civil War veterans, Daniel Webster Robbins (left) and Edward Everett Lapham, take part in the services at Green Cemetery on Memorial Day 1925. For many years in the 1920s, Lapham carried the flag of the Grand Army of the Republic during the procession, and Robbins called the roll at the Soldiers' Monument in the center.

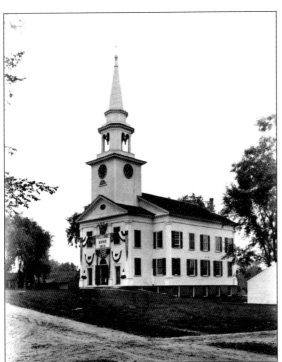

CARLISLE WELCOMES ITS SERVICEMEN. The fifth Old Home Day was held on September 1, 1919, and celebrated the safe return of Carlisle's soldiers and sailors from World War I. Public buildings, churches, and homes were decorated with patriotic bunting, as shown in this photograph of the First Religious Society.

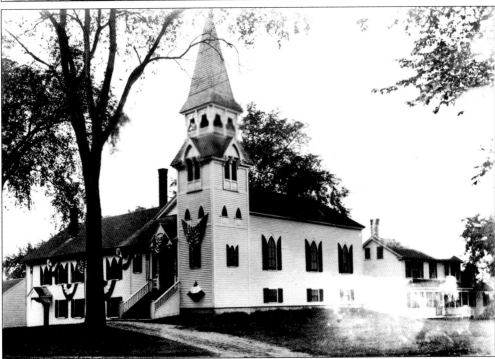

CONGREGATIONAL CHURCH DECORATED FOR OLD HOME DAY. The celebration that welcomed home World War I servicemen began with a flag raising at sunrise and the ringing of the church bells. The festivities included sports, a parade, a luncheon, a concert, speakers, a music program, and an informal dance that closed out the day.

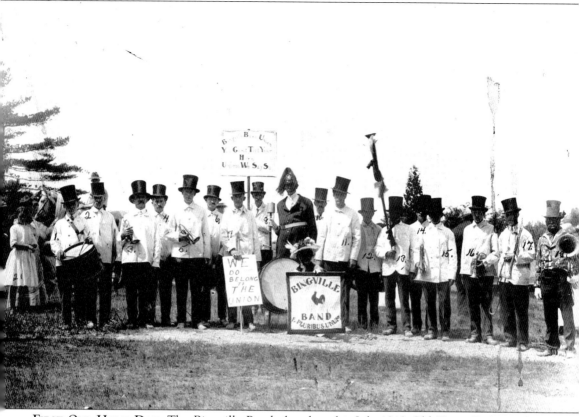

First Old Home Day. The Bingville Band played at this July 1912 Old Home Day. Band members include Ralph Gerow, Emil Peterson, James Anthony, Albert Davis, Palmer Pederson, Frank Heald, Carol Schoolcraft, William Barrett, Benjamin Heald, George Wilkins, Donald Davis, Alden Davis, Winthrop Puffer, Roy Hodgman, and James Taylor. The signs read, "Bingville Band Union—You Can't Toot Your Horn Unless We Say So" and "We Do Belong to the Union."

Committees

General
Granville Pierce, *Chairman.* George E. Wilkins, H. W. Wilson, E. B. Rose, W. B. Chamberlin, Warren C. Duren, Herbert P. Dutton

Organization
Edmund L. French, *Chairman,* P. A. Job, Lillian W. Ricker

Reception
Philip A. Job, *Chairman,* Edwin C. Currier, D. L. Chamberlin, Edna Currier, Grace Wilkins, Sarah E. Wilson, Mary T. Chamberlin, Herbert A. Lee, Mrs. Gilbert Taylor, Elmer Dow

Parade
H. W. Wilson, *Chairman,* E. C. Currier, F. J. Biggi, J. S. Anthony, W. B. Chamberlin, B. F. Blaisdell

Dinner
Lillian W. Ricker, Fred E. Robbins, Nettie O. Wilson

Entertainment
Mrs. D. W. Robbins, Grace H. Chamberlin, W. B. Chamberlin, Frank Wilkins, Edna Currier

Music and Finance
George E. Wilkins, James S. Anthony, Frank J. Biggi

Sports
J. S. Anthony, *Chairman,* Frank J. Biggi, W. C. Duren, Austin Davis, Herbert A. Lee

Refreshments
James H. Wilkins, Albert W. Davis, Fred E. Robbins, Anna Hanson, Edith L. Davis, Winifred Lee

Printing and Advertising
Edmund L. French, Granville Pierce, Gilbert Wilkins

PROGRAMME
FOR
OLD HOME DAY

Carlisle Centre, Mass.,

Tuesday, August 12, 1913

"Now let the merriest tales be told, And let the sweetest songs be sung, That ever made the old heart young."

The O. M. I. Fife and Drum Corps of Lowell will furnish music.

Press of E. L. French, Carlisle

OLD HOME DAY PROGRAM. This program for the second annual Old Home Day celebration was the first of many printed by Edmund L. French in his Carlisle print shop, the Wayside Press, which was located in his home on River Road.

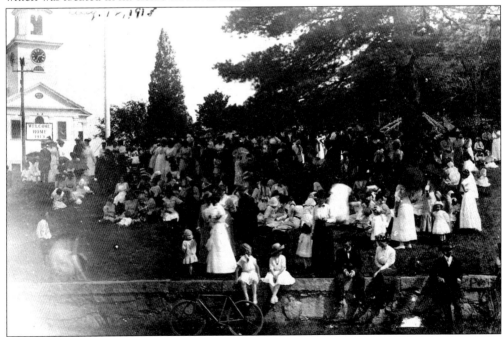

OLD HOME DAY, 1913. After a midday dinner, residents and those returning home to celebrate Old Home Day congregate on the town common for an afternoon of sports, music, and a milkmaid's contest. In the early years, Old Home Day was a celebration for welcoming home Carlisle natives who had moved out of town, and the event was not held on July 4, as it is now.

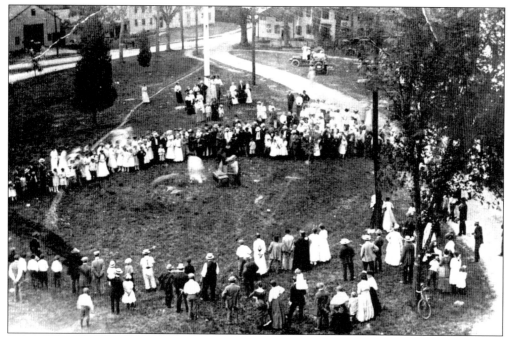

GREASED PIG CONTEST. In this early photograph, spectators at Old Home Day look on as a pig, covered with lard, is released. The winner of the contest was the man or boy who could catch and hold the pig for a specific amount of time. The winner was awarded the pig as a prize. Here, we assume that the blur in the center is the pig.

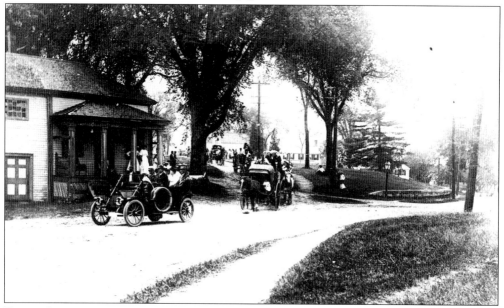

EARLY OLD HOME DAY CELEBRATION. This 1913 photograph of the second Old Home Day shows both cars and horse-drawn carriages entering the center of town. Over the years, the parade has been the highlight of the celebration, with every sort of vehicle—from fire engines to tricycles festooned with red, white, and blue streamers—taking part. Traditionally, children scamper to pick up candy thrown from the vehicles.

Forenoon Programme

10 A. M. Parade. Prizes will be awarded for the following features. First prize $2.00; second prize $1.00:

- Best Working Team
- Best Gentleman's Driving Team
- Automobile
- Float
- Novelty
- Trade Exhibit
- Other worthy exhibits will receive consideration

Chief Marshal of Parade, Edson B. Robbins

Putting the Shot
 Standing Broad Jump
 Standing High Jump
 Running Broad Jump
 Running High Jump
 Potato Races

Concert by the Drum Corps.

Dinner at 12.30. Coffee will be furnished free to all. Please bring your own Mugs and Pitchers.

Ice Cream and Lemonade will be on sale.

Afternoon Programme

2 P. M. SPORTS

Bicycle Race for Boys
50 yard dash for boys under 10 years
75 yard dash for boys between 10 and 16 years
50 yard dash for girls
100 yard dash open to all
Tug of War. Captains: E. B. Robbins, Charles Dunto
Relay Race for boys
Slow driving race
Three-legged race, Sack races, etc.

Entries may be made by any former or present res dent of the town. Make entries early to any member the committee on Sports.

First and second prizes will be awarded.

MILKMAID'S CONTEST

First prize $1.00, second prize 50¢ to the maids w will carry four cans of milk the farthest.

Music at intervals by the Drum Corps.

☞ *Please Register.* A book for the purpose will be fou in the Hall.

OLD HOME DAY PROGRAM. Shown here is the inside of the program from the second Old Home Day, held on August 12, 1913. (The program's cover is pictured on page 94.) As was the case in 1913, Old Home Day celebrations of today are full-day events. Old Home Day now begins early in the morning with one-mile and five-mile road races, followed by a pancake breakfast. The celebration continues with a parade, a country fair, and an art show. Contests such as frog jumping, corn husking, baking, and cake decorating, as well as a children's pet show, follow. A chicken barbecue and cakewalk round out the evening. The Old Home Day program, printed and distributed free to all residents of Carlisle, still uses the original format introduced 92 years ago by Edmund L. French.

Eight
Landscapes and Landmarks

THE SOLDIERS' MONUMENT. Dedicated to the memory of Carlisle's Civil War soldiers and installed on December 7, 1883, this Italian-marble statue represents the Goddess of Liberty. It is one of Carlisle's most recognizable landmarks and stands in the center of town. The granite base of the statue is inscribed with the names of 13 Carlisle soldiers who "died in their country's service." The statue was designed in Italy and stands seven and a half feet tall.

WASH DAY IN CARLISLE. This undated photograph, taken by Edmund L. French, shows laundry drying at the Wilkins Homestead, at the intersection of Bedford Road and East Street, in a view toward the town center. This scene was undoubtedly captured on a Monday, the traditional wash day.

CENTRAL BURYING GROUND. Located in the center of town (next to the current police station), the Central Burying Ground was established c. 1784, when the town acquired a half-acre of land for a cemetery. The stones here are almost all slate, and according to early custom, all face the rising sun. Some date back to 1778. Among the early settlers buried here are Rev. Paul Litchfield, Carlisle's minister for 46 years, who died in 1827, and his wife, Mary.

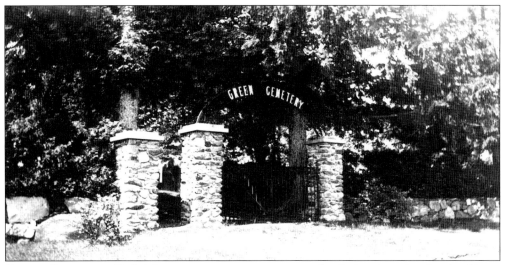

GREEN CEMETERY. Carlisle's main cemetery was once a family burying plot for the Green family. In 1837, the town bought a half-acre for $25 to enlarge "Green's burial ground" for townwide use. In 1875, Hannah L. C. Green donated an octagon-shaped summer house that still sits near the center of the cemetery. In 1897, more land was purchased from Thomas A. Green to expand the town's cemetery.

HEALD MEMORIAL ARCHWAY. This granite archway stands at the eastern entrance to Green Cemetery. A bronze tablet on one of the pillars of the arch reads, "Heald Memorial erected in respect to Major Benjamin F. Heald and his wife, Susan (Kimball) Heald of this town by their son, Benjamin F. Heald, 2nd, A.D. 1914."

WILSON MEMORIAL CHAPEL. In 1907, Capt. Horace Waldo Wilson gave Wilson Memorial Chapel to the town in memory of his parents, Mr. and Mrs. Horace N. Wilson. The one-story brick building seats about 50 people and houses an organ donated by the Unity Guild, a ladies group at the First Religious Society. The chapel is "for the free use of all of whatever creed or nationality," as declared in its dedication.

TOWN HEARSE. In 1808, Isaac Blaisdell, who owned a wheelwright shop, built a hearse for Carlisle that cost $29.75. A hearse house to shelter the vehicle was built the next year within the Central Burying Ground. The hearse was repaired in 1838 and was replaced in 1865. The "new" carriage hearse was bought and restored by a resident in 1950. Today, the town hearse belongs to the Carlisle Historical Society, and it is proudly displayed in the Fourth of July parade each year.

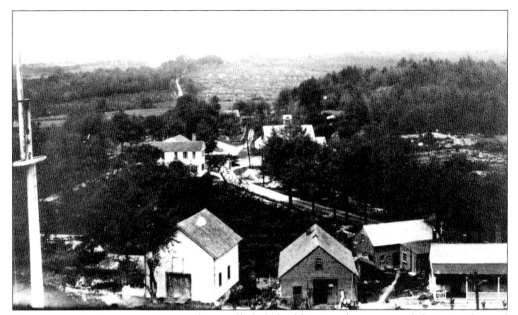

BLACKSMITH'S SHOP, C. 1900. The small dark building in the center of this view housed Carlisle's blacksmiths, the last of whom was Ingwald Otterson, who died in 1936. In 1938, this shop was taken down, leaving a large gap that is visible in the following photograph.

AERIAL VIEW, LOOKING WEST. This photograph was taken by Frances Lapham in 1942 from the steeple of the First Religious Society. The view looks across Carlisle Common toward open fields on the way to Westford. Concord Street is in the foreground. Note the space where the blacksmith's shop (photograph at top of page) used to be. The white vertical line that intersects the picture is the flagpole on the common.

CARLISLE-BEDFORD BRIDGE. The Concord River separates Carlisle from Bedford, and the first bridge between the two towns was built in 1795, with much of the labor being done by Carlisle residents. The cost of construction was shared by both towns. Over the years, much rebuilding and many repairs were done to the old bridge. In 1893, a new iron bridge over the Carlisle half of the Concord River was erected at county expense.

THUNDER BRIDGE. These errant planks, the iron structure, and the bridge's frequent state of disrepair created so much noise when automobiles crossed it that, in the early 1900s, the bridge became known as "Thunder Bridge." Today, modern bridge construction has created a safe and reliable bridge, from which peaceful views of the Concord River can be glimpsed, often with people fishing from their boats or from the bridge.

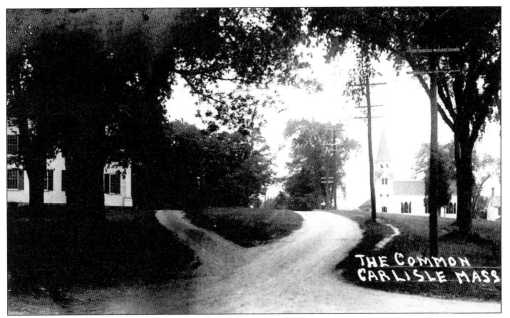

THE COMMON. This postcard of an Edmund L. French photograph shows School Street in the early 1900s. The dirt roads pass by the Congregational church (right) and the First Religious Society (left). Gone now are the towering elm trees, victimized by disease or the Hurricane of 1938. At the far right, a narrow, well-worn path has been made by schoolchildren walking to and from school.

TREE-LINED BEDFORD ROAD. As in the previous picture, these trees were also felled in the Hurricane of 1938. This is a view toward Carlisle Center from Bedford Road. A close inspection of this photograph reveals the Soldiers' Monument at the rotary.

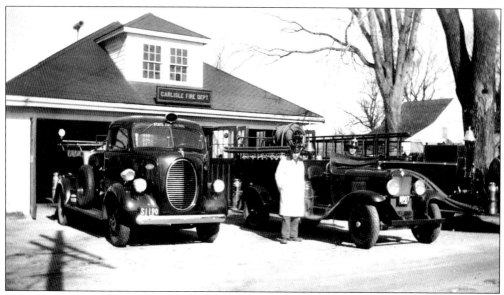

CARLISLE'S FIREFIGHTERS. At the end of 1916, Carlisle had a volunteer fire company of 24 men and one Ford fire truck. In 1927, the town established a permanent fire department, built a firehouse, and appointed Waldo D. Wilson as fire chief, a position he held for more than 50 years. The following year, through Yankee thrift and ingenuity, the fire department built a new pumping engine from the old fire truck with a motor that cost $30.

FIRE DEPARTMENT AT WORK. Taken in 1939, this photograph shows the first fire of the new year, near the Four Corners Farm at Acton and West Streets. The truck in the foreground is the pumping engine mentioned in the previous caption.

WHERE DIRT ROADS MEET. A group of people stands on School Street at the intersection with Church Street. The driveway at the top of the photograph leads past the steps of the Congregational church; the lower road in the center leads to the First Religious Society. The photograph is undated.

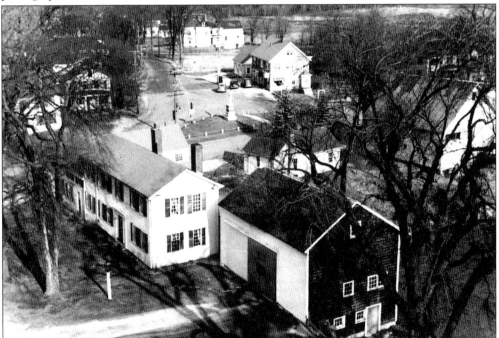

AERIAL VIEW OF THE CENTER. Taken c. 1940 from the belfry of the First Religious Society, this photograph of the center shows the Coombs house and barn on the corner of School Street, the rotary (with its granite posts and iron railing surrounding the Soldiers' Monument), Daisy's store, and the Texaco garage. Seen in the distance here are fields that are no longer visible from the road.

MARY A. GREEN, LIBRARIAN. Mary Green became Carlisle's first librarian in 1896. She conveniently resided just across the street from the library. Green had been assistant librarian since 1888, when the library was kept at 49 Concord Street, and she retired in 1938, marking 50 years as librarian. She classified the books in the collection long before there was an established card system.

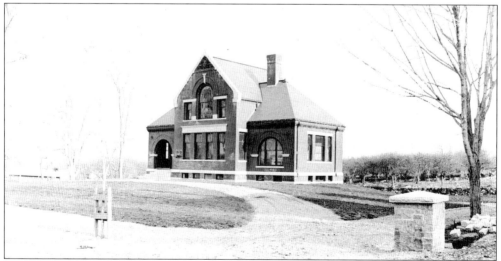

GLEASON PUBLIC LIBRARY. In 1894, Joanna Gleason, a former Carlisle resident, generously offered the town $6,000 to build "a brick building for a free public library" and an additional amount to furnish it. The library was dedicated in May 1896, and in March 1897, the library reported a collection of 1,421 books, with an average circulation per month of 135. This undated photograph shows the library with low trees behind it and a panoramic view that is no longer visible.

CARLISLE STATION. This tiny station was located two and a half miles from the center of Carlisle. The New York, New Haven and Hartford Railroad trains that ran from Framingham to Lowell made stops here in the late 1800s. Trains transported the mail and freight. In the early 1900s, there were three trains that ran both ways every day, and townspeople could travel by rail to Framingham or Lowell.

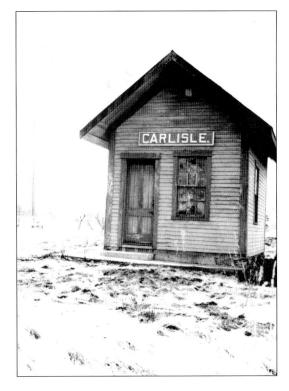

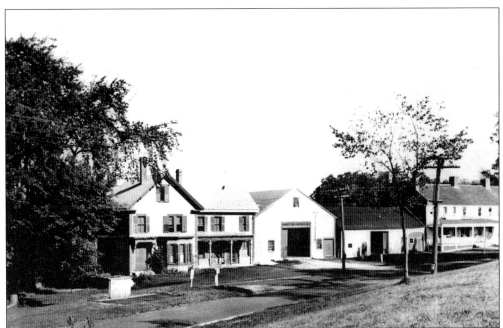

TOWN SCALES. In the mid-1800s, the town scales were placed at the corner of Concord and Westford Roads and were used by the public to weigh hay, lumber, and other heavy loads. The fee charged for each load weighed was initially 10¢ or 15¢ and was later raised to 25¢. In the background of this c. 1930 picture is the Charles E. Hastings home and barn, at 26 Westford Street.

A TYPICAL CARLISLE SCENE. This 1917 view would have been a common scene on many properties in town at the time. An ancient wooden gate stands open, making way for the rutted trail that bypasses stone walls. This peaceful scene was called "the Lower Gate" and was on the Rockland Road property of Mrs. B. P. Wilkins (Martha Fifield Wilkins).

Nine
FIRES AND STORMS

HURRICANE AFTERMATH, SEPTEMBER 1938. Young Carlisle residents stand in front of a large tree that fell during the Hurricane of 1938. From left to right are Barbara Daisy, Barbara Dutton, Beverly Dutton, and Bobby Daisy. Any Carlisle resident who lived through the hurricane remembers it well. The storm killed at least 500 people in New England and, in today's dollars, caused several billion dollars in damages throughout the region.

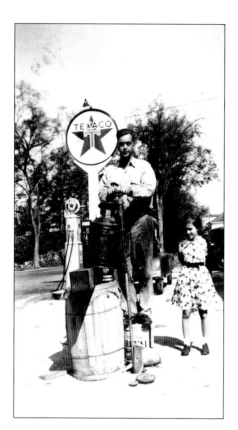

PUMPING GAS BY HAND. The Hurricane of 1938 left Carlisle with no electricity, and Fred Daisy, owner of the store and the gas station in the town center, pumped gasoline by hand for customers. Daisy and his daughter Barbara Daisy (Culkins) are shown in front of his store and filling station at 8 Lowell Road.

LAHM FAMILY SURVEYS DAMAGE. Members of the Louis D. Lahm family at 639 Lowell Road pose in front of a tree blown down by hurricane-force winds on September 21, 1938. Ruth Wilkins wrote in *Carlisle: Its History and Heritage*, "The force of the hurricane not only uprooted tremendous trees, but it caused the First Parish bell tower to sway so extremely that the bell rang several times."

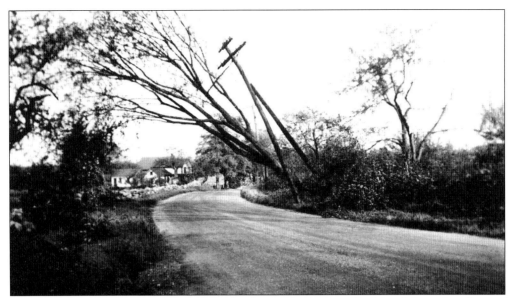

BEDFORD ROAD DESTRUCTION. Trees and utility poles along Bedford Road show the effects of the powerful winds that accompanied the Hurricane of 1938. This is a view from Carlisle Center toward the home of Charles Taylor at 101 Bedford Road. In addition to creating havoc on the roadsides, the hurricane ripped through woodlands throughout town.

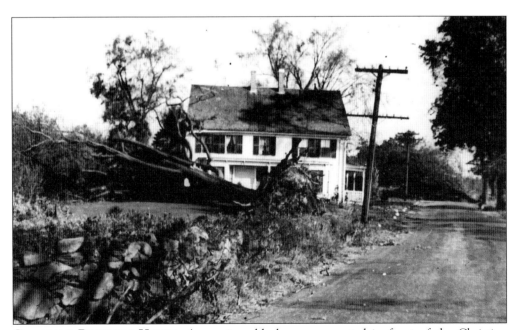

CHRISTIAN PEDERSEN HOUSE. A massive old elm was uprooted in front of the Christian Pedersen House, 698 Concord Road, during the Hurricane of 1938. Previously known as the Samuel Heald House, the residence was built in 1788 by Capt. Samuel Heald and is now the home of the Carlisle Historical Society.

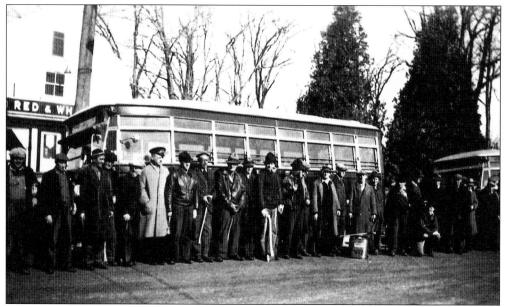

HURRICANE CLEANUP. Workers hired under the federal Public Works Administration (PWA) line up in front of the Red and White store on Lowell Street in April 1939. More than 800 men participated in "forest fire musters" that were conducted to clean up debris left by the Hurricane of 1938. The cleanup efforts also kept local woodlands clear in order to prevent forest fires.

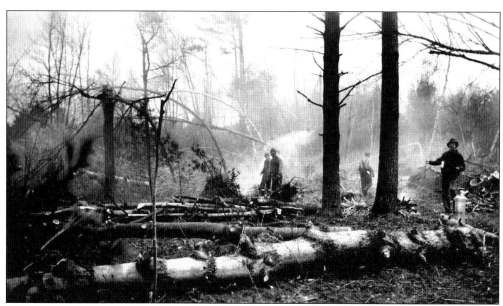

PWA CREW. In April 1939, a Public Works Administration crew clears away fallen trees in the Robbins Pines on Rockland Road. George H. Nobbs served as Carlisle's Works Progress Administration (WPA, which had oversight of the PWA) supervisor, managing workers and overseeing projects. As a result of the work, roads were cleared back 50 feet, woods roads were opened, and old woods roads that had been closed for 25 years were made accessible once again.

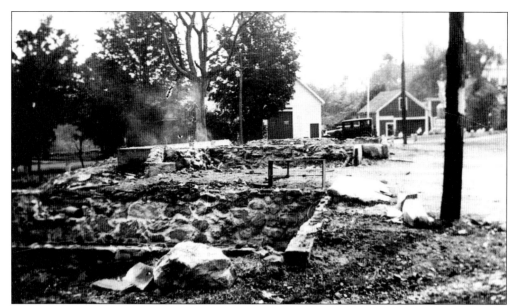

FIRE, CARLISLE CENTER, 1925. Smoke can be seen rising from the charred remains of James Houlton's store, located where Ferns Country Store now stands. In addition to the store, sheds and a barn were consumed by the fire, and adjacent buildings were partially damaged. As a result of the blaze, the town appropriated $1,000 for a new pumping engine, 1,250 feet of hose, and a truck to carry the new equipment.

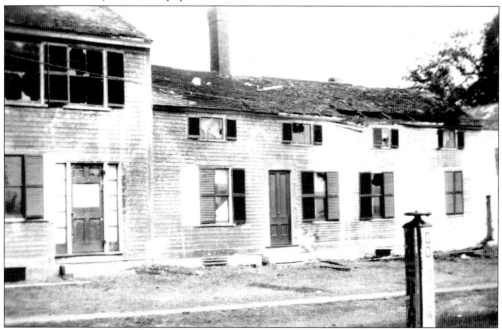

FIRE DAMAGE AT CHAMBERLIN HOUSE. The Daniel L. Chamberlin house, at 9 Lowell Road, stood across the street from Houlton's Store, which burned to the ground on May 27, 1925. The Chamberlin house was also damaged by the fire that at one point threatened to consume the entire center. Librarian Mary Green's house at 21 Bedford Road was among the other buildings that sustained major damage.

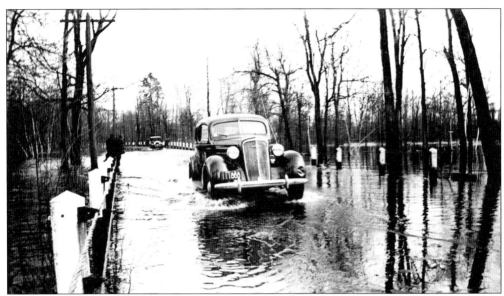

THE "ALL NEW ENGLAND FLOOD." A car makes its way across the Carlisle-Bedford Bridge during the "All New England Flood" in March 1936. The bridge crosses the Concord River at the Bedford-Carlisle line. Deep winter snow accompanied by heavy rain produced the flood and caused widespread destruction throughout the New England states.

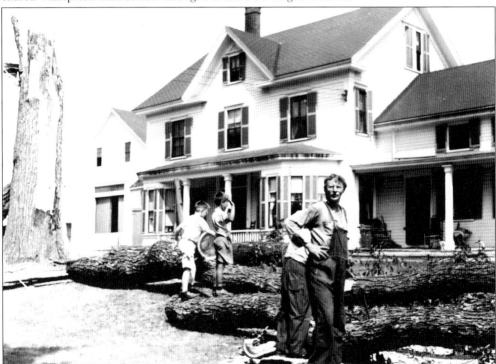

GREAT ATLANTIC HURRICANE OF 1944. From left to right, Roger Davis, Norman Davis Jr., an unidentified person (partially hidden), and Arthur Boydon examine a tree toppled by the Great Atlantic Hurricane of September 14–15, 1944. The big elm was in the front yard of the home of John Davis and Sarah Davis, at 549 Bedford Road.

ICE STORM, DECEMBER 1921. Downed trees and wires in front of the Gleason Public Library reflect the devastating effects of a major ice storm that occurred on December 1–2, 1921. The winter of 1921 was particularly difficult, as arctic storms, dominated by a La Niña effect, left ice more than three inches thick in some areas of New England.

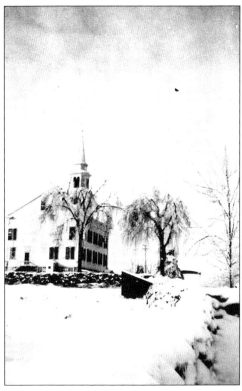

FIRST RELIGIOUS SOCIETY IN ICE STORM. The church is viewed from Bedford Road during the big ice storm of December 1921. Glazed trees and a snow-covered stone fence are beautiful to behold, but New England ice storms usually wreak havoc.

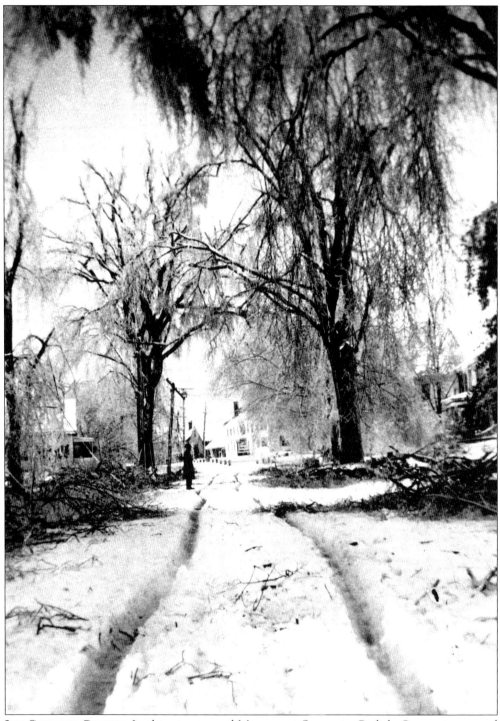

ICY CARLISLE CENTER. In this view toward Monument Square in Carlisle Center, ice-coated trees form a canopy over Bedford Road after the ice storm in December 1921. The town spent $159.44 to clean up after the storm, and the cemetery report included an entry for "removing rubbish after the ice storm of 1921."

Ten
PEOPLE

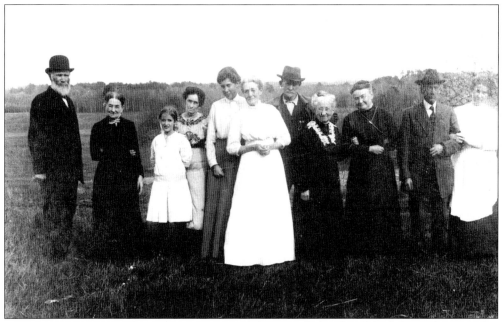

THE FRENCH FAMILY. Several generations of the French family of Carlisle, perhaps amid a family celebration, pose for photographer Edmund L. French. Those identified are, starting fifth from the left and continuing to the right, Alice French, Josie Proctor French (Edmund French's mother), George E. French (Edmund's father), unidentified, Lizzie Proctor, Hiram Proctor, and Edith French Davis. Alice and Edith French, both sisters of Edmund, were Carlisle schoolteachers, as was his sister Winifred, who is not pictured.

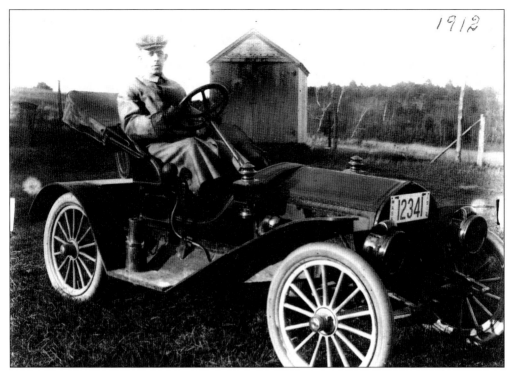

EDMUND L. FRENCH'S METZ. In 1909, French was working for the Metz Automobile Company in Waltham when he bought his first car. He waited until 1910 to register it and had the first license plate issued that year, No. 1234—which he had every year thereafter. Another early car in town was Capt. Horace W. Wilson's 1909 Cadillac, for which he hired a chauffeur instead of dealing with the uncertainties of early car ownership and driving.

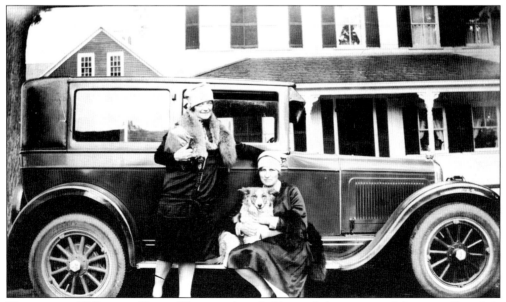

VISITORS TO 70 LOWELL ROAD. These unidentified but stylish women and their equally stylish dog pose with their Packard (vintage 1928–1930) outside the Blaisdell home in the early 1930s.

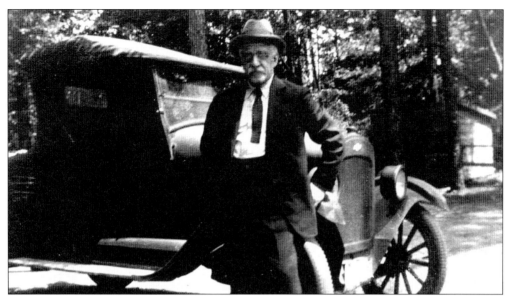

D. L. CHAMBERLIN'S CHEVROLET. Store owner and postmaster Daniel Lang Chamberlin stands with his Chevrolet roadster *c.* 1925. Around 1913, Chamberlin bought an International Harvester truck "with high carriage-size wheels, a top, and perhaps side curtains when needed." It had two moveable seats for carrying passengers instead of delivering groceries. The truck apparently caused quite a sensation in Carlisle.

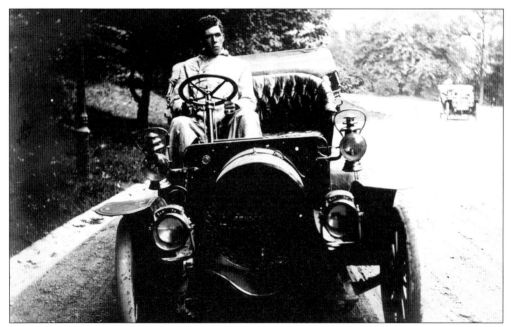

JAY FISK'S FORD. Jay Fisk and his wife, Jennie, lived in the old Litchfield Parsonage on Lowell Road. Fisk is shown driving his Ford Model F automobile *c.* 1905. He served on the first town planning board, which in 1932 investigated zoning for Carlisle, an innovative concept. For more than 40 years, Fisk was a member of the town's zoning board of appeals. In 1956, two-acre zoning was adopted, except in the historical district in the center of town.

ARTHUR AND HELEN LEE. These are the children of Herbert and Winifred Lee, photographed c. 1915. Helen married William Wilkie and became the librarian at the Gleason Public Library from 1950 to 1975. Arthur married Highland School teacher Minetta Decoster and moved to West Acton, where he was active in town affairs and served as selectman.

EMMA, MARY, AND CHARLES TAYLOR. Emma and Mary were twins, and Charles was their older brother. This photograph was taken c. 1892. Their parents died when the children were young, so the three lived with their grandparents, Stephen and Emeline Parker Taylor, at Wormwood Hill on Cross Street. As an adult, Charles Taylor lived at 101 Bedford Road; he was notable for keeping dozens of cats in his barn and maintaining a cat cemetery, complete with headstones.

MARIA TAYLOR AND DONALD LAPHAM. Maria Taylor holds her great-grandson Donald A. Lapham in 1906. Donald Lapham wrote *Carlisle: Composite Community*, which documents many of the old families in town. He was a respected historian and did much of his research around town by locating and exploring old cellar holes.

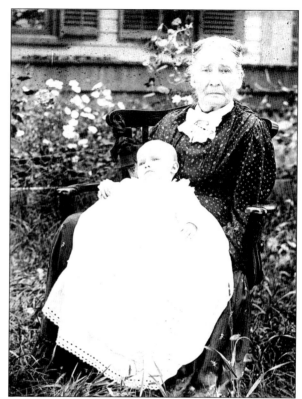

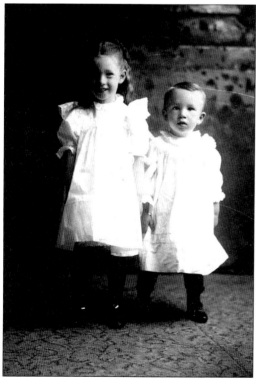

ETHLYN WILSON (GEROW) AND WALDO WILSON. These are the grandchildren of Capt. Horace W. Wilson. Ethlyn is pictured on the cover of this book in her baby carriage, alongside her proud grandfather. Ethlyn's brother Waldo held many town offices, and in 1927 was appointed Carlisle's first fire chief. Esther Wilson, Waldo's wife, was Carlisle's longtime police dispatcher, and Waldo's daughter, Sarah Wilson Andreassen, was town clerk for many years.

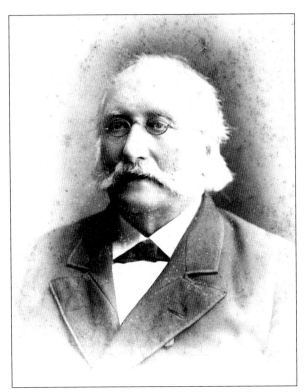

Rev. James Walker. Although he served as minister in the Carlisle Congregational Church for only nine years (June 1879–July 1888), Walker was much loved. Affectionately called "Father Walker" by his congregation, he lived in West Chelmsford and came to Carlisle on weekends, boarding with a local family. The church building was remodeled and expanded in 1882, during Walker's pastorate.

George Skelton. George Skelton bought River Road Farm c. 1836, and members of the Skelton family lived there until 1918, when it was sold to Mason Garfield, grandson of Pres. James Garfield. Skelton Road, which intersects River Road, is named after the family. George Skelton was a Carlisle selectman for 12 years; his first term began in 1869.

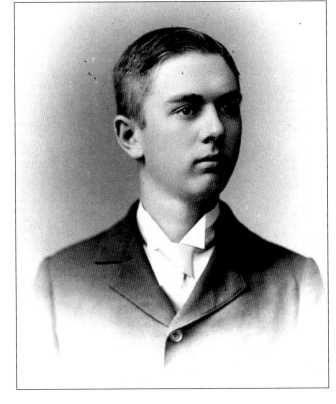

RUTH CHAMBERLIN. In this 1912 photograph by Edmund L. French, Ruth Chamberlin practices her violin. A daughter of the town's storekeeper and postmaster, she became a teacher and librarian and served as Carlisle's town clerk for 22 years. Chamberlin married "a sixth-generation man who was already active in town." (James Harry Wilkins.) In 1976, she published the acclaimed *Carlisle: Its History and Heritage*.

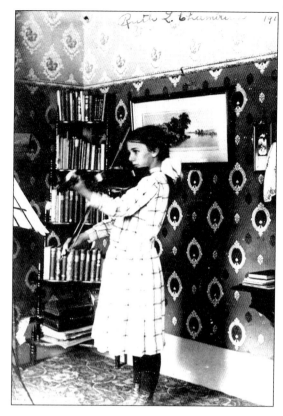

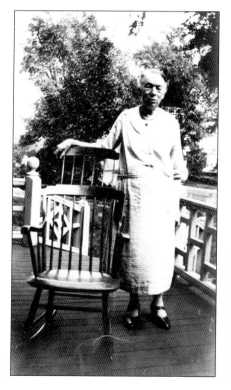

MARY A. GREEN. Born in Burlington, Massachusetts, in 1853, Mary A. Green was a teacher in Carlisle's West and Centre Schools. She married Thomas A. Green in 1880 and was active in town, serving on the school board that oversaw the consolidation of schools in the center. Her lasting legacy, however, is her 50 years of service as a town librarian. In this 1928 photograph, Green stands next to her grandmother's comb-back chair.

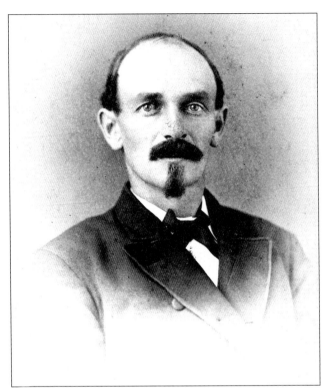

SIDNEY BULL. Sidney Bull came to town in 1870 to open a general store in the center. The store burned in 1879 and was rebuilt later that year. Bull was a noted historian, and in 1920, he published *History of Carlisle, Mass., 1754–1920*, a valuable compendium of the town's early years. The book is still a primary reference source for students of local history.

LESLIE AND ALBERT BULL. The small sons of Sidney Bull pose in 1892 in a fashionable portrait typical of the times. The children were born in Carlisle, but the Bull family moved away before they entered school here. Both boys graduated from Dartmouth College. The Bulls also had a daughter, Leila, who studied music at the New England Conservatory of Music and became a music instructor at Stanstead College in Quebec.

MARY AMANDA MARSH. In 1871, Carlisle resident Mary Amanda Marsh, daughter of Dr. Austin Marsh, started her own hair jewelry manufacturing company in Lowell, which was a notable achievement for a single woman of that time. Mary designed and produced pieces of jewelry made from human hair—wearing the hair of a deceased relative as a form of remembrance was a popular fashion statement in Victorian times. The business was successful for five years. Her business card appears below.

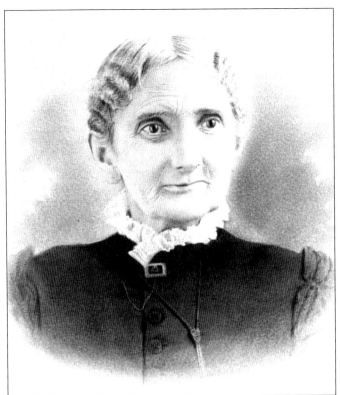

JOANNA GLEASON. In 1872, Carlisle established a public library, but it was located in rented space. In 1894, a gift from Joanna Gleason of Sudbury, formerly of Carlisle, enabled the town to build a library. Although she could not attend the dedication two years later, Mrs. Gleason wrote, "I see fruition of a hope which I had long cherished, to do something for the benefit of the town . . . for which I have never ceased to feel a daughter's affection."

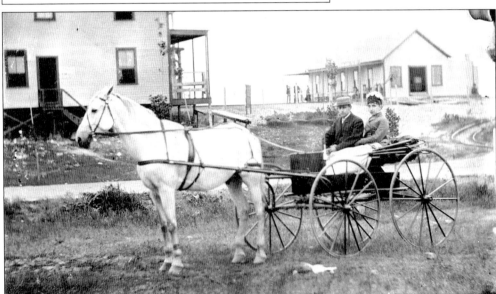

ELIZABETH ROBBINS BERRY. In this undated photograph, Elizabeth Robbins Berry rides in a carriage with an unidentified gentleman. Berry was an activist patriot, and in the late 1800s and early 1900s, she wrote and lectured widely about patriotism. Among her writings is a booklet, *Our Flag and Its Use*, which was published in 1914. Berry was also a personal friend of Clara Barton, founder of the Red Cross, and some of their correspondence is in the Carlisle Historical Society collection.

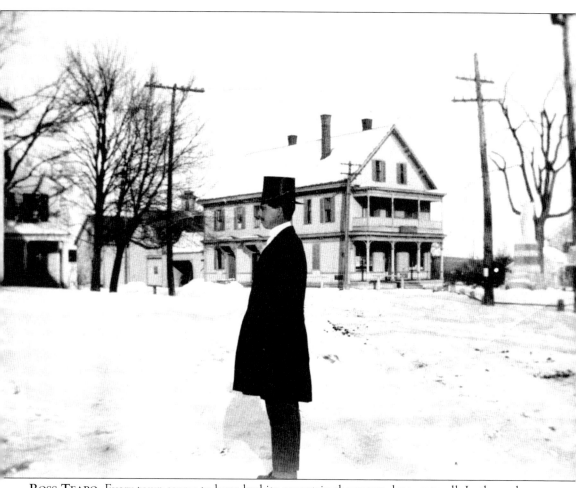

Ross Teabo. Every town seems to have had its eccentric characters, known to all. In the early and mid-1900s, Carlisle's resident character was Eugene Roswell Teabo, who was often seen around town in this melancholy garb. He was active in his community, as one of the organizers of the Carlisle Volunteer Fire Company in 1916 and one of its first volunteer firefighters. In 1925, Teabo was one of five park commissioners responsible for the town's acquisition of Spalding Park, the first land to be purchased for recreational use. This photograph is dated c. 1920. The old Carlisle Country Store is in the background.

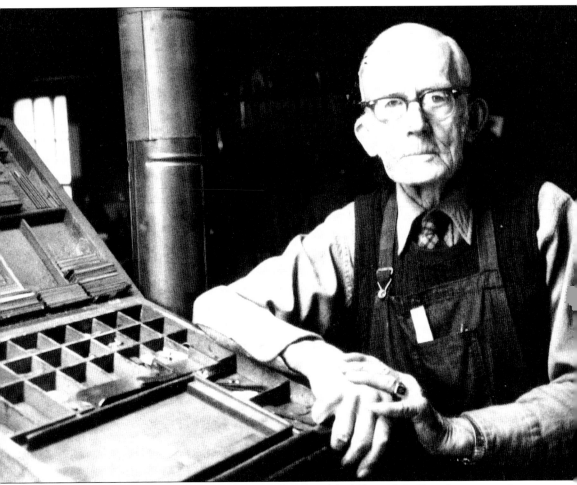

EDMUND L. FRENCH, PRINTER. Photographs of and by Edmund L. French, a man of many interests and talents, appear throughout this book. Born in Tewksbury in 1883, he moved to Carlisle at the age of one, attended town schools, and took an early interest in photography, a hobby that remained with him for life. Edmund French was a skilled carpenter who built his own home. He married Mary C. MacDonald of Medford in 1917, and they had two sons, Hector and Lewis. French worked for the Metz Automobile Company and, in 1929, established the Wayside Press at his River Road home, where he printed town warrants and ballots for town elections. French died in 1982 at the age of 99, having lived in Carlisle for 98 years. In 1976, the *Carlisle Gazette* wrote of French, "His keen mind, eager to create and record, resembles the temperament of the men of the eighteenth and nineteenth centuries, who mastered trade upon trade, profession after profession. Like those other earlier masters of diverse occupations, Ed French has found vitality in the elixir of devoted craftsmanship."